The world exists to be put on a postcard

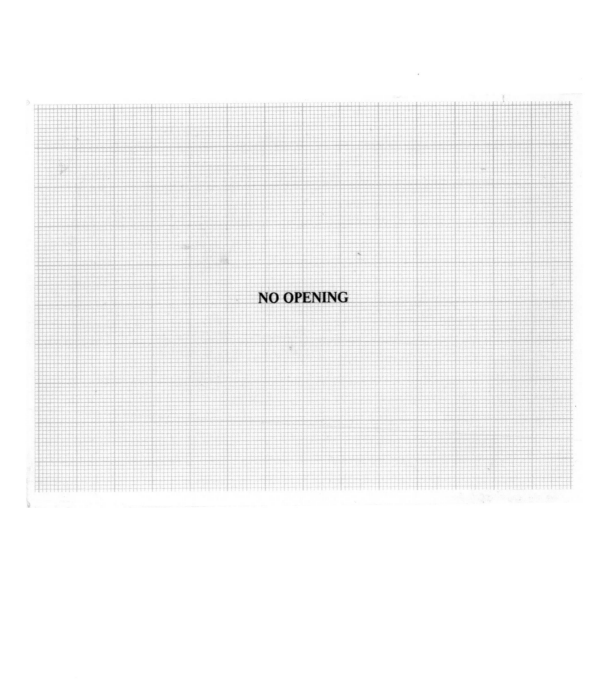
NO OPENING

The world exists to be put on a postcard

Artists' postcards from 1960 to now

Jeremy Cooper

 Thames & Hudson

 The British Museum

Previous
Jan Dibbets, *No Opening*, 1974
10.5 × 15.0 cm (4 ¼ × 6 in.)
Postcard announcement of solo exhibition from
19 October to 16 November 1974 at the Konrad
Fischer Galerie, Düsseldorf

Page 160
Daniel Buren, *Exit*, 1980
10.2 × 15.3 cm (4 ⅛ × 6 ⅛ in.)
Postcard announcement of work *in situ*, opening
2 December 1980 at John Weber Gallery,
New York

The world exists to be put on a postcard: artists' postcards from 1960 to now
© 2019 The Trustees of the British Museum/Thames & Hudson Ltd, London

Text © 2019 Jeremy Cooper

Images © 2019 The Trustees of the British Museum, unless otherwise stated on p.155

All illustrated works shown at the British Museum exhibition 7 February – 4 August 2019

Design © 2019 Thames & Hudson
Designed by Peter Dawson, gradedesign.com

First published in 2019 in paperback in the United States of America by Thames & Hudson Inc.,
500 Fifth Avenue, New York, New York 10110.

www.thamesandhudsonusa.com

Library of Congress Control Number 2018906157

ISBN 978-0-500-48043-4

Printed and bound in Slovenia by DZS-Grafik D.O.O.

For more information about the Museum and its collection, please visit britishmuseum.org.

Contents

Foreword

The British Museum holds 'collections of collections' from different epochs, cultures and civilizations and has done so ever since Sir Hans Sloane made his encyclopaedic founding bequest in 1753. Among the extraordinary riches of western works on paper in the Department of Prints and Drawings, built up largely through gift or bequest over the past two and a half centuries, are those of historically important ephemera. These include the wide-ranging collection from Georgian England assembled by Sarah Sophia Banks (1744–1818), sister of the naturalist and long-time Museum trustee, Joseph Banks, or the thirty-one albums of Christmas cards put together by Queen Mary, the wife of King George V, from 1872 to 1952. Acquisitions such as these are of huge interest to social and economic historians for they open a window onto the past that would otherwise be lost.

Jeremy Cooper, the foremost authority on artists' postcards from the 1960s to the present, has very generously made a gift of over 1,000 postcards to the British Museum. This book highlights a selection of more than 300 of these works, which Jeremy has assembled with scholarly care and passion. His wish to put together a collection for the Museum tracing the development of artists' postcards originated from a meeting in 2012 with Stephen Coppel, the curator in charge of modern prints and drawings at the Museum, who encouraged its formation.

Artists' postcards represent a category of object that is easily misunderstood and difficult to define. Jeremy Cooper considers the form as a work of art in its own right rather than the reproduction of a pre-existing image. They are created by artists for different purposes and by different means. Some are produced inexpensively in large numbers, others may be single works that have been collaged, hand-worked or manipulated. A carrier of an artist's idea and practice and often politically subversive in nature, the postcard circumvented the gallery or museum system and circulated widely in the public domain. Use of the medium rose with the movements of Fluxus and conceptualism in the 1960s, but was also taken up by artists to highlight pressing social issues such as feminism, the anti-war

movement and AIDS. As an artistic form it continues to be utilized today. In the age of Instagram, texting, Twitter and other forms of social media, it may seem that the artist's postcard is a redundant medium. But this book, and the accompanying exhibition, show just how witty, sharp and potent these objects can be.

It is my great pleasure to thank Jeremy Cooper for putting together and, most generously, donating this group of works, which has been selected with Stephen Coppel and Jenny Ramkalawon, the curator responsible for modern graphic art. The latter has performed the Herculean task of registering the entire group for the publication and exhibition at the British Museum. I also wish to thank Jeremy for writing this book, which so fluently maps out this fascinating field with a text that is both lively and packed with information and insight. The Museum is indebted to those who have given permission to reproduce their work in this publication. Finally I wish to acknowledge the dedication of Alice Nightingale, Senior Editorial Manager at the British Museum and her team, and the editorial and production team of our co-publisher, Thames & Hudson, who have created such a handsome and engaging book of Jeremy Cooper's milestone gift of artists' postcards to the Museum's collection of the contemporary world.

Hartwig Fischer
Director, British Museum, London

Introduction
Artists' Work with Postcards: Definition and Significance

One of the pleasures of artists' work with postcards is that, being made of non-precious material, they invite handling, ask to be included in our lives, picked up and turned over and puzzled about, shown to friends. The inexpensiveness of production encourages artists to experiment in their design, many effective examples of which remain undiscovered. Artists' work with postcards from the 1960s onwards is a concealed element in the history of contemporary art.

The guiding definition in selection for this book has been originality of expression specifically in the postcard, a work of art in its own right, not the reprinted image of something else. The collection excludes postcards that merely replicate artworks, as well as postcard-sized art not designed to be sent in the post – the first are reproductions, the second small paintings. An apposite description of the artist's postcard was given in 2000 by the poet and publisher Thomas A. Clark in his essay 'By the Morning Post' for 'Souvenirs', the exhibition of postcards designed by Ian Hamilton Finlay:

Each postcard is an original idea, not an illustration. If you own one of these postcards, you own an original work by this artist. Instead of acting as a reminder of something that exists somewhere else, that you may or may not have seen, it shares the same space as you, addressing you directly. As an opportunity to express a poetic idea, each postcard is considered as seriously as a book, a sculpture or gallery installation.[1]

Two interrelated postcards, designed by Yoko Ono (fig. 1) and Dieter Roth (fig. 2), both published in Heidelberg in the early 1970s by Klaus Staeck, combine many of the defining characteristics of the artist's postcard. Foremost is the fact that artistic ideas are expressed specifically as a postcard, unseen in any other form. In addition, these postcards are by artists whose other work has in different ways earned them a place in the history of contemporary practice – Ono through her Fluxus experiments in New York in the early 1960s, Roth in

the mesmerizing energy of his art making throughout his life. Furthermore, the postcards were published by Klaus Staeck. He encouraged many artists of distinction, including Joseph Beuys – several hundred of whose postcards Staeck published – to produce primary work for the medium, as well as designing and printing a large number of political postcards himself. Most importantly, these particular commercially produced postcards epitomize the style and ethos of their period. The notion of disclosure and exchange is clear: Roth drew over Ono's graphic postcard of 1971, *A Hole To See the Sky Through*, and the result was printed the next year by the same publisher as a second postcard, titled *D. Rot's AssHOLE, Looking at YOKO ONO*.

Contemporary art credentials are clearly exemplified in those postcards that display the hand of the artist in a unique work, such as Rachel Whiteread's hole-punching in 2005 of a found 1960s postcard of the Alps (fig. 129), to which she gives the quality of two-dimensional sculpture. Postcards printed in large numbers can equally be 'original' works of art, including certain exhibition invitations in the 1970s, designed by the artist for the occasion, with the address label on the card that was posted by the gallery, not folded and without an envelope – Richard Long, Carl Andre and Vito Acconci are three artists who spring to mind in this context. Artists occasionally design work for dual purposes, such as Peter Kennard in his photomontages for the Campaign for Nuclear Disarmament (CND) in the late 1970s and early 1980s, intended for simultaneous use as posters as well as postcards. And then there are self-contained sets of postcards, some commissioned from dozens of selected artists, notably the Image Bank boxed sets of 1971 and 1977 (figs 148, 149), all of work designed for postcards and encompassing unique images by, for example, Edward Ruscha and Sol LeWitt, published in Vancouver and exhibited as postcards at the National Gallery of Canada, Ottawa.

Other sets sustain a different kind of originality, as in *Stilkunde an Beispielen*, published in 1974 by Städtisches Museum Mönchengladbach in a boxed edition of 330, with rules and text (fig. 3). The aim of this delightful postcard game, to be

played by one or more persons, is to match the twenty postcards by contemporary artists to the appropriate reproductions of twenty old postcards. The instruction page ends: 'To start, undo the index file and lay out in alphabetical order. There is no time limit. A solution is printed inside the back cover.'

Egalitarian is the vital word concerning postcards. Until recently postcards were part of everyone's life, displayed on the mantelpieces of urban flats and pinned to the walls of artists' studios. They have influenced the creation of radical new works of art – Ellsworth Kelly noted in conversation with the curator Hans Ulrich Obrist in 2008: 'The first postcard I did when I came back from Paris in 1953 I sent to a friend. It has a [collaged] piece of a Gauloise cigarette blue paper and a red curve. And it was the first curve I did!'[2] Kelly's reference is to the importance of his subsequent colour-field, abstract canvases of curves.

Artists still work with, and on, postcards, cutting, scraping, collaging, painting, embroidering and erasing to make unique pieces. Others, particularly those drawn to the use of words, prefer to print their postcards by letterpress, screen print or rubber stamp. The rubber-stamp specialist Guy Schraenen defined the subject in remarks made about the series of postcards that he published in 1974 in Antwerp, including work by the concrete poets Henri Chopin and Brion Gysin: 'In this first serial, I want to present fifteen personalities which are true creators, and who for this edition have been "creating" works, so that these cards are not reproductions but "original post-cards".'[3]

Artists' work with postcards is divisible into categories according to numerous different criteria: by date, style, topic, content, function, presentation, nationality or technique, for instance. The book is divided into these different sections: 1960s and 1970s; Graphic Postcards; Postcard Invitations; Political Postcards; Altered Postcards; Portrait Postcards; Sets of Postcards; Composite Postcards; Recent Postcards. One of the pleasures of the subject is that, because of the large numbers of postcards by artists and the global scope of material, such choices are bound to be personal and could not possibly be comprehensive. The artist Tacita Dean, a lifelong collector and maker of postcards (fig. 172), wrote in 2018 about categories: 'It goes well until you come across an anomaly, and the anomaly makes you create a new description and a new category, and it goes well again until the next anomaly and the next category, and so on and so forth.'[4]

Postcard work comes in multiple forms, from the complex compositions of Susan Hiller's *Addenda* (fig. 154) to the open-edition single image documentation of performance events by Francis Alÿs (fig. 168). In addition, there are boxed sets in which art-historical pearls lurk, such as Gordon Matta-Clark's postcard with hand-guided cuts (fig. 4), published within the 1977 Image Bank series. Other artists' postcards, though progressive in concept, are more traditional in production method. The photographer Stephen Shore made in 1971 a set of ten postcards (fig. 5) from images of the small town of Amarillo, Texas, and on his long journey around America in 1973 proceeded to place these on postcard racks wherever he went, to be taken free by passers-by. In the process of making this work, Shore established his individualistic photographic style, unposed and anti-aesthetic, in work that exists only as a postcard and that influenced the eye of a whole generation of American photographers.

Attention to the accessible nature of forms of expression such as the postcard may help avoid a danger pointed out by the video and performance artist Martha Rosler in her book *Culture Class* (2013): the descent of successful artists to become 'handmaidens to wealth and power'.[5] Rosler's book *Service: A Trilogy on Colonization* (1978), published in New York by Printed Matter, Inc., began as a series of postcards sent to friends every five or six days, an alternative way of making art. The influential curator and writer Lucy Lippard, from the same generation of radical American women, said in an interview of 1969:

The artists who are trying to do non-object art are introducing a drastic solution to the problem of artists

being bought and sold so easily, along with their art.…
The people who buy a work of art they can't hang up or
have in their garden are less interested in possession.[6]

In an essay of 1999 on the film-maker Andrei Tarkovsky, Susan
Hiller wrote of her attraction to postcards: 'I like to work with
materials that have been culturally repressed or misunderstood.'[7]
Invitation postcards, an important section of the collection,
fulfil this role. Though originally distributed in their hundreds,
they were mostly thrown away by their art-world recipients and
can often now be difficult to find.

To the as-yet-few serious observers of the subject, artists'
postcards are absconders from the controlling clutches of the
modern art market. The influential pioneering expert in this
field was the late Steven Leiber, a San Francisco collector and
dealer, who curated the show 'Extra Art: A Survey of Artists'
Ephemera, 1960–1999' at the California College of Arts and
Crafts in San Francisco in 2001 and the Institute of Contemporary
Arts (ICA) in London from 2002 to 2003. Leiber noted that
for a solo show at the Solomon R. Guggenheim Museum,
New York, in 1970, Carl Andre insisted that there was no
private view and that the public were let in free at this normally
exclusive time. Klaus Staeck spoke at the Memorial Service to
Joseph Beuys in Bonn in 1986: 'Nothing – apart from constant
public indignation over the prices for which a few outstanding
works were traded – got Beuys more worked up than any
attempt at separating his works from the accompanying
political intentions.'[8]

The art-historical significance of the subject is embodied
in the announcement postcards published and mailed by the
Düsseldorf gallery owner Gerry Schum, for a series of exhibitions
of videos he presented between 1969 and 1973 by a number
of the most celebrated artists of the time, including Joseph
Beuys, Lawrence Weiner, Jan Dibbets, Richard Long, Robert
Smithson, Gilbert & George and Daniel Buren. His selection
of still images from films and videotapes for use in invitation
postcards and the style of print and reproduction are of

absorbing interest, revealing the experimental beginnings
of a new form of art making that, nearly fifty years later, has
come to international prominence. Back then, the work shown
at Schum's Videogalerie, often in partnership with his friend
Konrad Fischer, the Düsseldorf art dealer, was usually shot
by Schum himself, often in arduous physical circumstances,
in response to the complex aesthetic requirements of the
artist, using large tripod-mounted cameras for 16 mm film
and experimental techniques for the video shoots. The results,
to judge by his invitation postcards in this book (figs 15, 44, 47,
57, 87, 135), were exceptional. In miserable contrast to the
originality of his work, Gerry Schum died in 1973 at the age
of thirty-four in his mobile studio-home parked in a Düsseldorf
street, from a sleeping-pill overdose.

Gilbert & George are among the best-known contemporary
makers of postcard works and were represented for a number
of years by the leading London art dealer of the period, Anthony
d'Offay. Unusually in the art world, d'Offay is appreciative
of postcards, writing in an email of 2014: 'What a source of
knowledge, ideas and creativity is to be found in this ubiquitous
and modest medium.'[9] Gilbert & George printed on the inside
of the invitation to their 'Crusade' exhibition at the Anthony
d'Offay Gallery in 1982:

What is a Post Card Piece?

The form of the Post Card Piece lends itself
to the expression of finer
feelings, stirring thoughts and
beautiful views ...
They are our shields, our swords, our
emblem, our vision, our tombstone and our
life-masks

1 Yoko Ono, *A Hole To See the Sky Through*, 1971
10.5 × 15.0 cm (4 ¼ × 6 in.)
Published by Klaus Staeck, Heidelberg

2 Dieter Roth, *D. Rot's AssHOLE, Looking at YOKO ONO*, 1972
10.5 × 15.0 cm (4 ¼ × 6 in.)
Published by Klaus Staeck, Heidelberg

Yoko Ono's postcard was printed in 1971 by Klaus Staeck, who began publishing his own postcard designs in 1962, before setting up a company to promote original postcard work by Joseph Beuys, Wolf Vostell, Hans Haacke and many others. Dieter Roth appropriated the Ono card, already published with a hole punched through the middle, and added his own drawing, while also writing over the printed inscription. Staeck printed this altered version in 1972.

A HOLE TO SEE
THE SKY THROUGH

YOKO ONO
'71

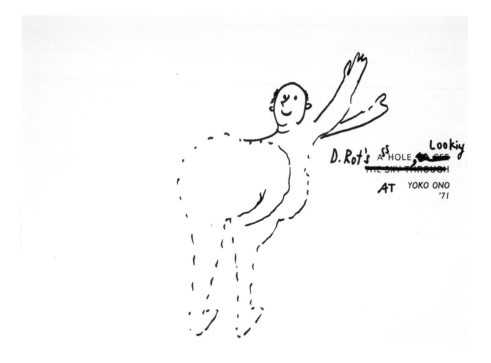

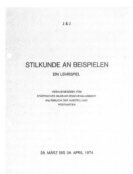

3 Various artists, *Stilkunde an Beispielen*, 1974
10.5 × 15.0 cm (4 ¼ × 6 in.)
Boxed set of 40 postcards published
with rules of play by Städtisches Museum
Mönchengladbach in an edition of 330

Players match the twenty postcards by
contemporary artists to the appropriate
reproductions of twenty old postcards, and
then lodge the pairs in the indexed folder of
styles. The twenty artists (and their designated
styles) are: Ben Vautier (Literaturism); Joseph
Beuys (Agitatorism); Christian Boltanski
(Babyism); Marcel Broodthaers (Museumism);
Daniel Buren (Zebraism); Christo
(Neodrapism); Chuck Close (Identityism);
Marcel Duchamp (Jocondism); Robert Filliou
(Festivityism); Gilbert & George (Duetism);
Jean Olivier Hucleux (Requiemism); Edward
Kienholz (Veteranism); Yves Klein (Eroticism);
Jean Le Gac (Kodakism); Ferdinand Léger
(Proletariatism); Hermann Nitsch (Offertoryism);
Claes Oldenburg (Hot-Dogism); Panamarenko
(Santos-Dumontism); Pablo Picasso
(Underbombism); George Segal (Gorgonism).

4 Gordon Matta-Clark, *Untitled*, 1977
9.8 × 15.2 cm (3 ⅞ × 6 in.)
Cut postcard from boxed set by forty-eight
different artists published by Image Bank,
Vancouver, in an edition of *c*. 750

Made a year before he died in his mid-thirties,
this postcard by Gordon Matta-Clark, with
hand-guided cuts on plain gloss-white card,
relives on a small scale his major artworks of
radical architectural incision, slicing clapboard
houses in half and cutting giant circular holes
in brick buildings (fig. 86). As Matta-Clark's
other progressive art projects included setting
up in 1971 a New York café, for which Robert
Rauschenberg, John Cage and others designed
food, physical examples of his work are rare,
adding significance to this postcard. Image
Bank, founded by the performance artists
Michael Morris and Vincent Trasov in 1969
in Vancouver, arranged for this set of postcards
to be exhibited extensively in Canada and
the USA.

5 Stephen Shore, *Greetings from Amarillo – Tall in Texas*, 1971
Each card 8.9 × 14.0 cm (3 ⅝ × 5 ⅝ in.)
Complete set of ten postcards printed by Dexter Press published for the artist in an edition of 560

During the summers Stephen Shore used to visit friends in Amarillo, Texas. In 1971 he made a set of ten postcards from photographs he had taken, which he commissioned the leading commercial postcard makers at the time, Dexter Press, to print in their standard style. On the two long working road trips Shore made in 1973 from New York to California, up into Oregon and back via Missouri and the Great Lakes, he placed copies of the Amarillo cards in postcard racks in the towns he passed, for the taking.

1. 1960s and 1970s

During the 1960s and 1970s postcards were a significant means of experimental expression by recording conceptual artworks, performances and specially designed postcard invitations to gallery exhibitions. All these artists' postcards are original works of art, even when published in multiples, because they were designed specifically for this purpose, unique in appearance. In form and content, they provide instructive insight into the advanced art making of the period. In addition, almost all these postcards contain a story, within themselves and in their wider implications, stories that are seldom told.

The Fluxus movement in both the USA and Europe was central to the developing use of artists' postcards, the origins of which lie in the mid-1950s at Black Mountain College, North Carolina, with performance events organized by John Cage (fig. 52), with the assistance of Ray Johnson (fig. 124). Cage is credited with developing the term 'Happening' in his pivotal class at the New School for Social Research between 1956 and 1960, attended by Allan Kaprow (fig. 41), who gave the first so-called public performance, *18 Happenings in 6 Parts*, at the Reuben Gallery in New York in 1959. George Brecht, Geoff Hendricks (fig. 14) and a number of other Fluxus artists also attended Cage's classes, later making expressive use of postcards. In his *Notebooks I, II & III June 1958 to August 1959*, published in Cologne in 1991, Brecht gives details of Cage's lectures in New York.

In narrative terms, Richard Hamilton's concertina postcard *To Mother* (fig. 6) is a reminder of the artist's time teaching in Newcastle upon Tyne in the 1960s, for he makes use of a found commercial postcard of nearby Whitley Bay. During his Newcastle years, Hamilton rescued for the university museum a wall from Kurt Schwitters's *Merzbau* (unfinished, 1948) in Cumbria, as well as working in his studio office on remaking Marcel Duchamp's *Large Glass* (1915–23). Hamilton's pupils included Tim Head (fig. 23), whom he helped to spend the year of 1968 in New York as studio assistant to Claes Oldenburg (fig. 38).

Hamilton's postcard projects embody collaboration and invention, notably in *The Rotham Certificates* (fig. 12), which he and Dieter Roth made in 1977 in memory of Marcel Broodthaers, at Cadaqués, the Catalan fishing village north of Barcelona. In 1933 Duchamp had been introduced by Salvador Dalí to Cadaqués and proceeded to spend most of his summers there. To help his friend Hamilton over the sudden death of his first wife in 1962, Duchamp invited him to stay in Cadaqués, after which Hamilton bought his own studio house and, in his turn, invited artist friends to stay, including Joseph Beuys and David Hockney.

The composer John Cage was an ever-present influence throughout this period, inspiring Hamilton to make the postcard *composer (to john cage)* (1972), a glazed white die-cut card with the instructions 'PLACE 'COMPOSER' OVER ANY PICTURE POSTCARD SO THAT THE BOTTOM RIGHT HAND EDGES ALIGN THEN EXAMINE THE CHANCE COMPOSITION DEFINED BY THE RECTANGULAR HOLE'. The work relates to a postcard-connected project in 1969 at the Museum of Contemporary Art, Chicago, *Art by Telephone*, an invitation that had appealed to Hamilton. Cage was himself a fan of postcards, composing in 1983 a piece called *Postcard from Heaven*, for between one and twenty harps and two solo voices.

Cage and postcards feature in the life of painter Tom Phillips, who was known in the late 1960s mostly for his music, playing with the experimental Scratch Orchestra and writing compositions to be performed on piano by the virtuosic John Tilbury. In his postcard *Mappin Wall* (fig. 22) it was a natural extension of Phillips's collecting of pre-1920 postcards to apply Edwardian tints to a photograph of Tilbury playing at the Kunsthalle Basel during a reception at an exhibition of Phillips's work there.

Concrete poetry is another link, with its combination of poetry, music, graphics and sculpture. Phillips's contemporary Barry Flanagan (fig. 87) was an early convert to concrete poetry, influenced by performances at Bob Cobbing's Better Books in Charing Cross Road, London, near Saint Martin's School of Art, where he, Bruce Mclean, Richard Long and Gilbert & George were students at the time. In 1968 Flanagan lectured at Cobbing's Antiuniversity of London, which operated for a year at 49 Rivington Street, Shoreditch.

During this period performance became a significant element of artistic exploration, unique images of which tend to have been published in postcard form. Hermann Nitsch's performances (fig. 54) began in the early 1960s and featured the crucifixion of sheep, for which he was arrested both at home in Austria and in London. The Irish writer Sara Baume described these in *A Line Made by Walking* (2017), the novel which she titled after a work by Richard Long: 'Generally, Nitsch's performance of *Orgien Mysterien Theater* involves animal sacrifice, the kneading of flesh, the drinking of blood, sex organs, entrails…The point being made has to do with how mankind has forgotten its inborn proclivity to violence and slaughter. How, instead, we are all too busy washing our hair, our car. Plucking our guitar strings, our eyebrows.'[10] The radical characteristics of certain works are directly communicated to later generations in the unpretentious immediacy of original postcards. Cultural distinctions can also be observed through postcard documentation, as with Chris Burden's *Big Wrench*, presented in 1979 at San Francisco's avant-garde space La Mamelle (fig. 53). Also on the West Coast of the USA, Paul McCarthy made in 1978 for personal use a series of postcards of his iconoclastic performance of the previous year, *Hollywood Halloween* (fig. 55).

A distinct branch of expression in experimental forms emerged in postcards by women in the 1970s, ranging from the explicitly provocative self-portraiture of Lynda Benglis (fig. 33) and Hannah Wilke (fig. 36) to the more directly political work of Charlotte Moorman (fig. 29), Annette Messager (fig. 32) and Barbara Kruger (fig. 35). Moorman, a ubiquitous figure at Fluxus events, was a musician as well as aesthetic agitator. In 1961 she helped Yoko Ono mount an avant-garde concert at the Carnegie Recital Hall, playing on solo cello the Ono composition *A Grapefruit in the World of Park*. Ono was a charismatic early member of Fluxus, many of her colleagues discovering new sounds through sessions in her New York loft. In 1963 she made a woodcut of a Japanese man baring his bottom, from which emerge the words 'Fluxus Vaudeville Tournament'. The notably independent German artist Hanne Darboven developed her own systems of patterned marking in words and numbers, regularly expressed on invitation postcards. In the exhibition catalogue *No Title* (1981), of Sol LeWitt's personal collection of work by other artists, Darboven is quoted as saying: 'Words and images are part of nature. Numbers on the other hand are an invention – perhaps the only real invention man has made.'[11]

Progressive dealers in contemporary art contributed significantly to the scene, reflecting their artistic backgrounds, as witnessed by the quality of invitation postcards. Konrad Fischer (fig. 131), for example, had studied at the Kunstakademie Düsseldorf from 1958 to 1962 alongside Sigmar Polke and Gerhard Richter. With those two artists he put on in 1963 an exhibition in a defunct butcher's shop, including paintings by himself, exhibited under his mother's maiden name of Lueg. On opening his gallery in 1967 Fischer showed international artists, giving the first solo exhibitions by the English artists Richard Long and Bruce McLean, in 1968 (fig. 96) and 1969 (fig. 95) respectively. His rival German dealers were: Alfred Schmela, who commissioned the modernist architect Aldo van Eyck to build his gallery in 1971; René Block, who opened galleries in Berlin in 1964 and New York in 1974 (fig. 91), both marked by memorable Joseph Beuys performances; and the video specialist Gerry Schum, with Lawrence Weiner's unexpected *Beached* (fig. 44) in 1970. The largest contemporary art dealer in America in the 1970s, Leo Castelli, printed and mailed fine invitation Jumbo Post Cards by Bruce Nauman in 1968 (fig. 42) and Jasper Johns in 1969 (fig. 97). On the front of Castelli's large invitation postcard to Lawrence Weiner's show 'Silver Anniversary' (1995), the ageing dealer and artist are photographed sharing a glass of wine, in celebration of the anniversary of Weiner's first show at the gallery, in 1971.

A number of other New York dealers made use of informative photographs on their postcard invitations, in the 1970s and 1980s notably the John Gibson Gallery with shows by Acconci (fig. 39) and Hutchinson (fig. 136), and the John Weber Gallery with Haacke's important Mobil statement (fig. 102) and Buren's *Exit* postcard, illustrated as the endpiece, closely related to George Brecht's *EXIT* Word Event cards for Fluxus in 1962, now in the Braun/Lieff Collection Museum Ostwall, Dortmund.

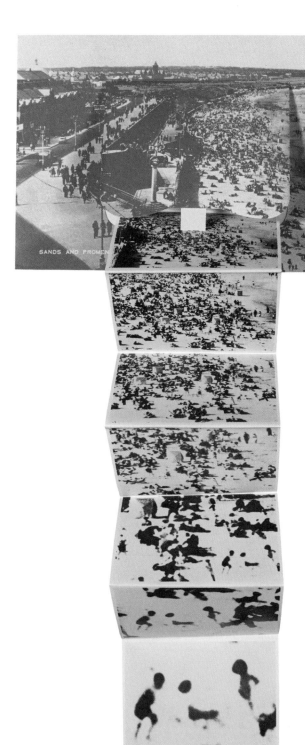

6 Richard Hamilton, *To Mother*, 1968
12.7 × 20.0 cm (5 × 7 ⅞ in.)
Pull-out postcard published by William N. Copley
in the first Shit Must Stop (SMS) folder in an
edition of *c.* 2,000

The image on Richard Hamilton's contribution
to the folder of multiples issued by the
American artist and collector William N. Copley
was taken from an old postcard of Whitley Bay,
near Newcastle upon Tyne. The artists were
each paid £100 for their contributions. A flap
in the middle folds up to release a concertina
of eight smaller cards, showing increasingly
blown-up black-and-white images of this
section of the beach, similarly used by Hamilton
in his screen print *People* (1968). In the same
year, he also made a sculptural version of
To Mother, over 2.4 metres (8 ft) high, made
of cardboard and aluminium, with photographs
of the same images in a hinged concertina.
That work was exhibited in the Hamilton
retrospective at Tate Modern, London, in 2014.

7 Richard Hamilton, *Whitley Bay*, 1966
10.5 × 15.5 cm (4 ¼ × 6 ⅛ in.)
Hand-tinted photograph published as a postcard
by Robert Fraser Gallery, 69 Duke Street, London

Richard Hamilton's first use of the postcard
aesthetic in a painting was his extraction in
People (1965–66) of a detail from a postcard
of the beach at Whitley Bay. In 1966 Robert
Fraser, Hamilton's dealer at the time, used the
artist's hand-tinted Whitley Bay photograph
of 1965, itself the enlargement from a detail
of a commercial postcard, to make another
postcard. Hamilton remarked: 'I find it
astonishing that a flick of a shutter over a
coating of silver emulsion can snatch so much
information about that milli-second of activity
over half a mile of beach at Whitley Bay one
summer's day…I marvel that marks and shapes,
simple or complex, have the capacity to enlarge
consciousness.'[12]

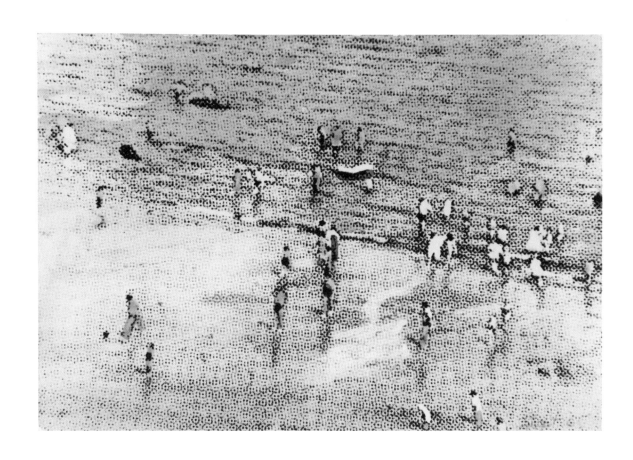

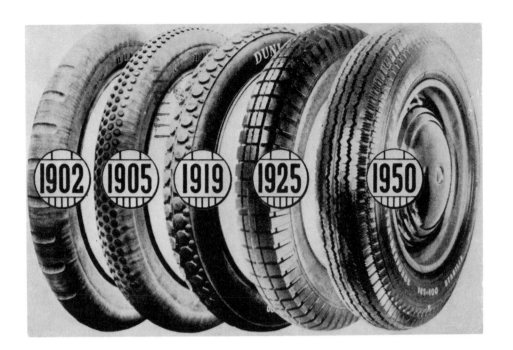

**8 Richard Hamilton, *Five Tyres
Remoulded*, 1972**
10.0 × 15.0 cm (4 × 6 in.)
Invitation postcard for solo exhibition at Nigel
Greenwood Gallery, London

The image is taken from the black-and-white
illustration of a rack of five car tyres that dated
from 1902 to 1950. Since 1951 Hamilton had
kept this cutting, which he had removed from
the French magazine *Technique et Architecture*.
He had experimented with it in the studio for
a number of years before finding the artistic
expression that pleased him. One of the earliest
examples was the screen print *Five Tyres
Abandoned* (1964). Variations of these tyres
appear in a number of Hamilton's significant
drawings and a silicone relief cast, though
this invitation postcard is his first publication
of the original image, at the leading young
contemporary art gallery in London at the time.

**9 Richard Hamilton, *Polaroid Portraits*,
1972**
10.5 × 22.5 cm (4 ¼ × 8 ⅞ in.)
Postcard invitation from Mathews Miller
Dunbar to Richard Hamilton exhibition from
5 to 22 October 1972 at the Photographers'
Gallery, London

The image on this invitation, posted to Richard
Hamilton's friend and fellow artist Joe Tilson,
illustrates one of the group of polaroid portraits
of Hamilton taken by artist friends, in this case
by Man Ray, who died in 1976. In holding a
frame around his head, Hamilton was directly
acknowledging the similar action in Ray's
own self-portrait photograph of 1922. Begun
in 1968, this group of works comprised, by
their conclusion in 2001, polaroid portraits
of Hamilton by 128 artists, as featured in the
retrospective of his work at Tate Modern,
London, in 2014. Tilson also made use of
postcards, notably in his tall print of 1965,
inspired by a concertina of New York postcards.

10 Richard Hamilton, *Sunrise*, **1974/1975**
17.0 × 25.0 cm (6 ¾ × 9 ⅞ in.)
Giant Post Card published in Munich by Verlag
Schellmann, this example posted with a note by
the artist's wife Rita Donagh on 18 September
1975 to the art historian and critic Norbert Lynton

The postcard image is taken from a Richard
Hamilton pastel of 1974, itself painted from a
tourist postcard of the coast at Cadaqués – the
Spanish town where Hamilton had a summer
studio – at sunrise, except the local church is
replaced by a large turd. In the same year he
made a number of small pastels of postcard-
inspired sunset scenes alongside this single
sunrise, a work still owned by the Bombelli
family, owners of Galeria Uno at Cadaqués.
In the same year he created a full-colour
collotype from the sunrise pastel.

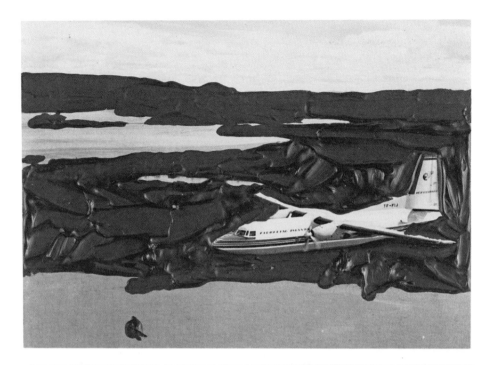

11 Dieter Roth, *Fokker Friendship*, 1969
10.5 × 15.0 cm (4 ¼ × 6 in.)
Two identical postcards with thick brown acrylic paint applied in different ways by Dieter Roth, together sent from Iceland to Hansjörg Mayer in Germany on 1 May 1969

The printed caption on the reverse of these commercial postcards reads 'Icelandair's Fokker Friendship aircraft over Reykjavik'. Painted on in opposing patterns, one of the postcards is dated 1 May 1969, the handwritten note in different coloured inks covering both postcards, concerning the payment of 3,100 DM to the printer whom Roth and Mayer were using at the time. As a student at the Kunsthaus in Zurich, Mayer made his way in 1963, at the age of twenty, to America via Icelandic Airlines, stopping off in Reykjavik to introduce himself to Roth, an ex-pupil of his professor's. They became friends and over the years Mayer has published hundreds of the artist's prints and postcards.

Opposite
12 Dieter Roth and Richard Hamilton, *The Rotham Certificates*, 1977
10.5 × 15.0 cm (4 ¼ × 6 in.)
From complete set of thirty-seven postcards published by Galería Cadaqués and Edition Hansjörg Mayer in an edition of 1,000

The postcards relate to collaborative paintings by Roth and Hamilton exhibited the previous year at Cadaqués to mark their friend Marcel Broodthaers's sudden death the year before. The postcards differed from the paintings, often substantially so, and were conceived from the start as unique works of art, a 'certificate' for each of the paintings. Broodthaers had been developing an exhibition primarily for dogs, to be hung low on the gallery walls at Cadaqués, of items that would appeal to dogs, such as sausages, which feature in several of the Roth/ Hamilton postcards. In a musical addition to the exhibition, the artists requisitioned Chispas Luis, a large local dog renowned for his bark, to record with themselves (using vocals and guitar) a double album titled *Canciones de Cadaqués*.

The Rotham Certificates

im juli 1977 arbeiteten richard hamilton und dieter roth
an einer reihe von bildern, die ende juli unter dem
titel 'collaborations' in der galeria cadaqués zum
ersten mal ausgestellt wurden und durch 6 museen in
england der schweiz deutschland holland und
spanien wandern
die 37 postkarten des vorliegenden satzes zeigen
reproduktionen der sogenannten 'certificates'
gehörend zu je einem der 37 bilder
»... Bildern, so angestrengt - und doch so leichtsinnig -
aufgestellt, dass dieser Widersinn die allergrösste
Anstrengung sowohl beim Mitarbeiter als auch beim
Betrachter fordern werde. Dumme Schauerszonen,
widerwärtige Süssigkeiten oder ausgekocht Einfältiges
(wie erfinderisch und aufreizend immer) sind nicht
leicht zu ertragen. Die Ergebnisse des
Zusammenstosses (die Bilder), im Ehrgeiz entstanden
ebenso tiefgründig wie leichtfertig aufzutreten,
brachten ein Problem zurück: Mehrdeutige Qualität.
Roth schlug vor, diese Mitteilungsschranke mittels
eines Zertifikats ('Certificats') zu überwinden: einer
je zu einem Bild gehörenden, gesondert hergestellten,
gemalten oder gezeichneten Fassung, welche die
Eigenschaften (ob negativ oder nicht) des 'Originales'
in konventionell annehmbarer Form zeigen sollte.«
(siehe einleitung 'über die »collaborations«' in
'collaborations of ch. rotham' ein katalog für eine
wanderausstellung auch verlegt von galeria
cadaqués und edition hansjörg mayer)

Richard Hamilton
Dieter Roth

The Rotham Certificates

13 Dieter Roth, *120 Piccadilly Postcards*, 1977
10.5 × 15.0 cm (4 ¼ × 6 in.)
From complete set of 120 postcards published in printed paper band by Edition Hansjörg Mayer

For his *120 Piccadilly Postcards* Dieter Roth adapted one of the postcards that Richard Hamilton's wife, Rita Donagh, had sent to him over the years. Roth's overpainted postcards were first made into a book in 1977 by Hansjörg Mayer as *96 Piccadillies*, co-published with Martin and Diane Ackerman. The images in *96 Piccadillies* were printed two to a page, the backs with graphic scissors and dotted lines to indicate the design divisions. Mayer reissued these images as individual postcards for *120 Piccadilly Postcards*, held by a plain paper band, the extra cards printing in German and English the introduction to the Ackerman book.

14 Geoff Hendricks, *Sky Post Cards*, c. 1974
9.0 × 14.0 cm (3 ⅝ × 5 ⅝ in.)
Four from the set of thirteen self-published by the artist solely as postcards at his Sky Works, New York

Geoff Hendricks, who was involved with Fluxus from the outset, described himself as a 'cloudsmith' to account for his obsession with skies – a subject that he used on hoardings, on canvas, in painted objects and in numerous installations and performances. Hendricks developed his first sky paintings between 1964 and 1965, extended in April 1966 into pieces such as *Sky Billboard*, which was executed by sign painters on a large hoarding at the corner of 42nd Street and 5th Avenue in New York. Soon after this he made the first in the series of *Sky Post Cards*, which, as he stated in conversation in 1977 with fellow Fluxus artist Dick Higgins, 'were some of the first artist cards…a nickel's worth of sky'.[13]

The German painter Gerhard Richter made related studies of clouds in a group of postcard-sized colour photographs in his archival work *Atlas* (1962–89), taken from the windows of aeroplanes, twenty-eight of which are now in the British Museum collection. Richter also painted on old postcards, twelve of which were illustrated by Anthony d'Offay in December 1989 for his privately printed new year's calendar.

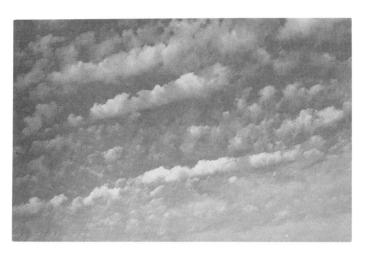

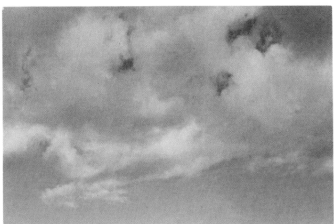

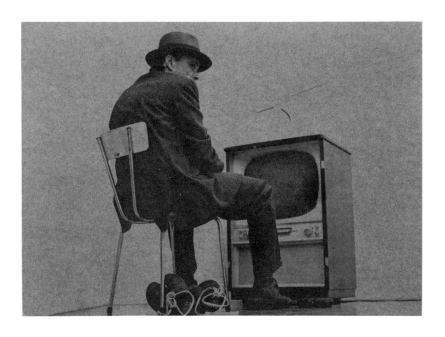

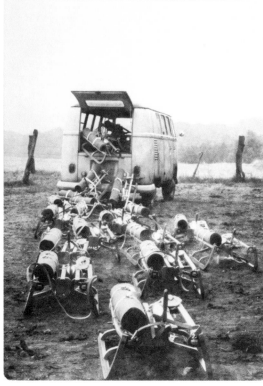

15 Joseph Beuys, *Filz-TV*, 1970
15.0 × 21.0 cm (6 × 8 ⅜ in.)
Postcard invitation to video screening on
30 November 1970 at Gerry Schum's
Videogalerie, Hanover

Joseph Beuys first gave the performance
shown in this video in 1966, a visualization
of his ideas about television communication,
which begins with his removal of a felt curtain
over the screen. The video revolutionary Gerry
Schum died alone in 1973 at the age of thirty-
four in his mobile home in Düsseldorf, from a
sleeping-pill overdose. Beuys told the Stedelijk
Museum, Amsterdam, on the occasion of its
1980 exhibition devoted to Schum's video
project: 'It is of the utmost importance to break
through the triangle [of studio, gallery, collector]
and to reach as big an audience as possible.
Schum took a big step in the right direction
with his television gallery.'[14]

16 Joseph Beuys, *Beuys – Penck*, 1972
15.0 × 10.5 cm (6 × 4 ¼ in.)
Postcard announcement of shows by two artists
at Staatsgalerie Moderner Kunst, Munich

The illustration on the front of the postcard is a
black-and-white photograph of Joseph Beuys's
piece *The Pack* (1969) with a Volkswagen
camper van and sledge, unusually taken in a
landscape setting. The work, which is now
owned by the Staatliche Museen Kassel
was shown at Tate Modern, London, in 2018.
Immediately after the death of his friend Beuys
in 1986, Ralf Winkler, who worked under the
pseudonym A. R. Penck, made a lithograph
titled *Memorial for Joseph Beuys*.

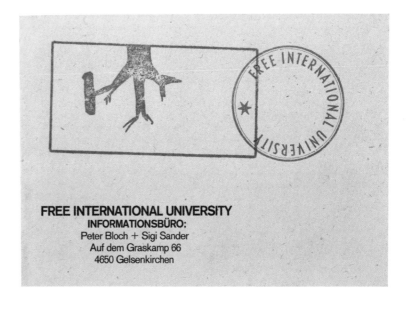

FREE INTERNATIONAL UNIVERSITY
INFORMATIONSBÜRO:
Peter Bloch + Sigi Sander
Auf dem Graskamp 66
4650 Gelsenkirchen

17 Joseph Beuys, *7,000 Eichen / anläßlich der Documenta VII, Kassel 1982*, 1982
15.0 × 10.5 cm (6 × 4 ¼ in.)
Postcard published by Free International University, signed by the artist, and the rubber-stamped envelope in which this card was presented, No. 53 in an edition of 245

For 'documenta 7' in 1982 Joseph Beuys proposed to plant 7,000 oak trees throughout the city of Kassel, each accompanied by its own basalt stone. For the exhibition the stones were stacked on the grass in front of the Museum Fridericianum, the pile gradually reducing in size as each tree was planted. The project was seen by Beuys as participating in the greening of cities, undertaken over a period of five years and spreading to other cities around the world. The Free International University (FIU) was founded by Beuys, the public benefits of which he regularly proclaimed, accompanied by his blackboard illustrations. The postcard was sent out by the FIU from their information office in Gelsenkirchen, run by Peter Bloch and Sigi Sander.

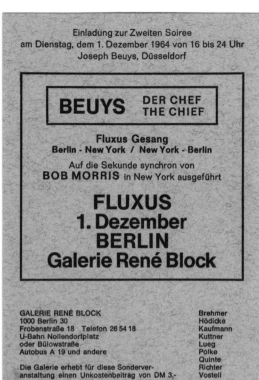

**18 Joseph Beuys, *Der Chef. The Chief.
Fluxus Gesang*, 1964**
15.0 × 10.5 cm (6 × 4 ¼ in.)
Postcard invitation to performance on
1 December 1964 at Edition 2, Galerie René
Block, Berlin

Joseph Beuys insisted that his performance
must last for the length of a normal working
day. Beginning at 4 p.m. and continuing
until midnight on 1 December 1964, it was
designed to oppose concepts of traditional
authority. Art followers found him rolled up
in a felt blanket in a corner of René Block's
newly opened avant-garde gallery. Concealed
inside the blanket, Beuys could be heard but
not seen, his voice projected through a sound
system, making odd sounds, syllables and
sentences into the microphone held in his
felt retreat.

**19 Ben Vautier, *The Postman's Choice*,
1965/1967**
10.5 × 15.0 cm (4 ¼ × 6 in.)
Flux Post Card identical on both sides,
published by Fluxus

The instructions for use of this postcard
(created in 1965 and published in 1967) are
that it should have different addresses on
either side and postage stamps on both and be
placed in a postbox, leaving the post office to
choose who to deliver it to and which of the two
stamps to frank. George Maciunas, instigator
of the Fluxus movement, was impressed and
wrote to Ben Vautier in 1966: 'This double-
faced postcard is a WONDERFUL PIECE!!!…
This postcard is work of genius, absolutely
wonderful. I can see the Post Office being all
gummed up in confusion!!'[15] Vautier admired
the often minimalist style of action of Maciunas
and his close colleague George Brecht, saying:
'With George [Brecht], it can just be a blink.'[16]

20 Dick Higgins, *This is the Pre-Sphincterist Period in our Arts and Culture, c. 1970*
8.8 × 14.0 cm (3 ½ × 5 ⅝ in.)
Postcard, self-published in Canal Street, New York

As George Maciunas's right-hand man in the early days of Fluxus, Dick Higgins was involved in many of the group's events. At the Fluxus festival held at Wiesbaden in September 1962 he performed *Danger Music No. 2*, in which the artist Alison Knowles – his wife – lathered and shaved his head bald. Founder of the Something Else Press in 1963, Higgins printed his own postcards. In his essay 'Intermedia', first published in his Something Else Press newsletter of 1965, Higgins outlined the radical ideas on art that he had developed after attending John Cage's lectures, including awareness of the danger of art-world materialism and hypocrisy. He published a gold card stating in the various versions of his name that 'Dieter Roth is magnificent', with instructions on the reverse that the postcard be signed and posted to Roth at home in Iceland.

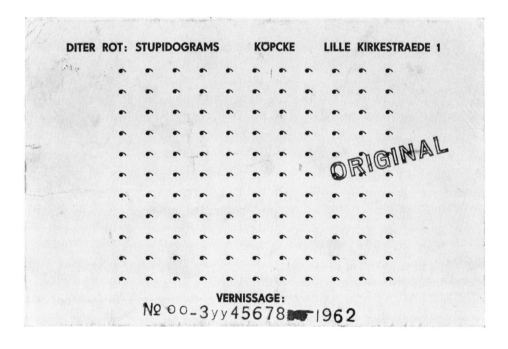

This is the Pre-Sphincterist Period in our Arts and Culture. Sphincterism will be launched next November, when its sensibility emerges.

21 Dieter Roth, *Diter Rot: Stupidograms*, 1962
10.0 × 15.5 cm (4 × 6 ⅛ in.)
Rubber-stamped postcard invitation for the show at the Galerie Köpcke in Copenhagen, addressed in Roth's hand to Ben Vauthier [Vautier] in Nice, posted on 18 July 1962

The sending of this invitation to Ben Vautier documents Dieter Roth's involvement with the Fluxus group in its early years, displayed also in the publication in 1967 of his pamphlet *A Look into the blue tide (part 2)* at Dick Higgins's Something Else Press. Roth also knew Fluxus habitué Daniel Spoerri, who wrote the foreword to his friend's 1966 exhibition 'Snow', in which he described their drinking bouts together in Berne – both artists were Swiss. Arthur (Addi) Köpcke himself made a number of Fluxus works published by Edition Hundertmark in Berlin.

DITER ROT: STUPIDOGRAMS KÖPCKE LILLE KIRKESTRAEDE 1

ORIGINAL

VERNISSAGE:
Nº 00-3yy45678 1962

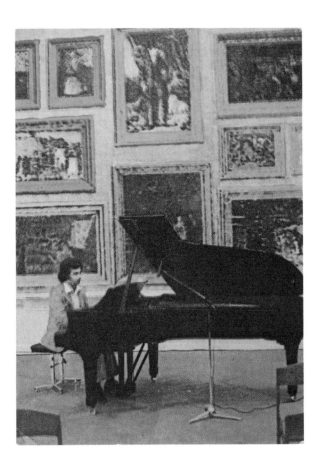

22 Tom Phillips, *Mappin Wall*, 1970–76
14.0 × 10.0 cm (5 ⅝ × 4 in.)
Self-published postcard of *John Tilbury Playing at the Basel Kunsthalle* (1975/76) at a reception for the exhibition 'Installation Mappin Art Gallery'

In his paintings Tom Phillips makes regular use of old postcards, which he began gathering in the 1960s. He has gone on to form extensive groups of specified subject matter, exhibited at the National Portrait Gallery, London, and many other museums. The caption on the back of this *Mappin Wall* postcard reads: 'Printed in Bradford after a version tinted in Camberwell of a photo taken in Basel of a work painted in Camberwell after a postcard tinted in Hessen based on a photograph taken in the Mappin Art Gallery, Sheffield.' The paintings Phillips made of the gallery were shown there in 1987, marking the conjunction of the artist's 50th birthday and the 100th anniversary of the Mappin's foundation.

23 Tim Head, *Untitled*, c. 1985
15.0 × 10.5 cm (6 × 4 ¼ in.)
Unique collage with washing-machine instructions on a 1974 Musées Nationaux postcard of the Mona Lisa

At art school in Newcastle upon Tyne Tim Head was taught by Richard Hamilton. In this work Head acknowledges his teacher's admiration for Marcel Duchamp, who altered the same Leonardo image. In 1986 the Manchester City Festival and Artangel made a set of eight postcards from Head's billboard project *Acceptable Levels* (1986), which they had commissioned.

24 Wolf Vostell, *Multimedia Environment*, 1968
10.5 × 15.0 cm (4 ¼ × 6 in.)
No. 7 in Serie 3 Kassel, published by Klaus
Staeck's Edition Tangente for 'documenta 4'

Published in the 'Vietnam year' of 1968, this
postcard reflects Wolf Vostell's opposition
to war. In the same year he published *Miss
Vietnam and Texts of Other Happenings*,
recording his often shocking performance
pieces, mostly presented under the auspices
of Fluxus, including Festum Fluxorumin
(Wiesbaden, 1962). Al Hansen wrote in
*A Primer of Happenings and Time/Space
Art* (1965): 'In Vostell's happenings one
infers instantly the terror and depravity and
awfulness of the concentration camp, of the
dictatorship, of the monolithic state stamping
on the individual…One thinks in social terms;
one thinks in terms of politics. Such is the
great value of Vostell in the happening world.'[20]

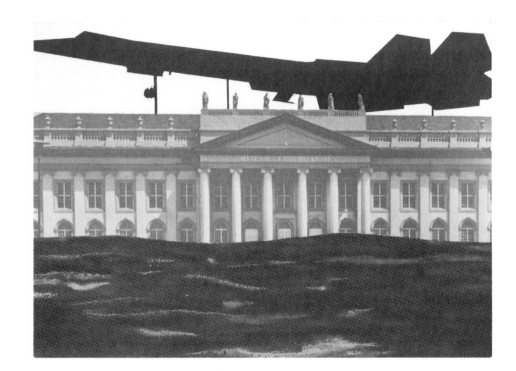

25 Bill Gaglione and Tim Mancusi, *Dada Land*, 1975/1977
9.8 × 15.2 cm (3 ⅞ × 6 in.)
Postcard published by Image Bank, Vancouver,
in an edition of c. 750

Inspired by the example of Fluxus, the Canadian
artist Anna Banana set up her own mail-art
network in 1971 and began circulating *Banana
Rag*. Through her publication she met fellow
mail-artist Bill Gaglione and by June 1973
was living with him in San Francisco. The
performance piece *Dada Land* was created by
Bill Gaglione and Tim Mancusi, known as the
Dada Brothers, for the first *Banana Olympics*
in San Francisco's Embarcadero Plaza in
1975. Banana's 'games' were a celebration
of participation, creative performance and
anti-competition, with events such as the
Bureaucrat Marathon, where competitors were
tied in red tape and instructed to run three
steps forwards, two steps backwards and one
step to the side.

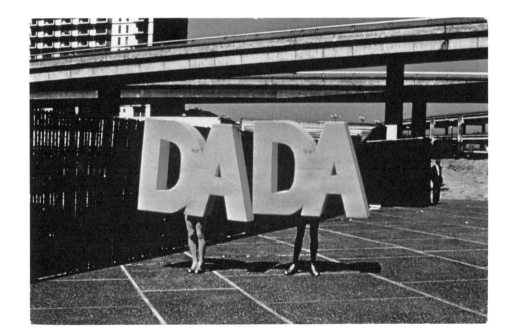

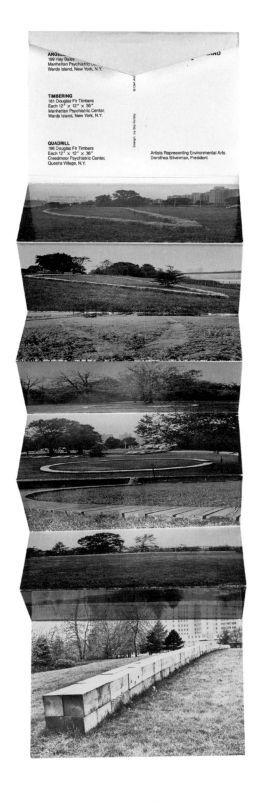

26 Carl Andre, *Three Works on Land*, 1979
10.0 × 14.0 cm (4 × 5 ⅝ in.)
Concertina of nine postcards of land works
photographed by Bevan Davies and Ivy Sky
Rutzky, an Artists Representing Environmental
Arts (A.R.E.A.) Project, Manhattan Psychiatric
Center, Wards Island, New York

The three Andre works, each with three images
in situ, were *Angellipse*, a large oval of 199 hay
bales in a field, *Timbering*, a flat circular path of
181 Douglas fir timbers and *Quadrill*, a double
stacked line of Douglas fir blocks. This set
of postcards represents the primary record of
the existence of these works, which illustrate
a remark made by Andre in 1967: 'I realized the
wood was better before I cut it than after. I did
not improve it in any way.'[21] In the same year
as *Three Works on Land*, Andre exhibited *200
Douglas Fir Timbers* (1979) issuing a postcard
invitation to the unveiling on 3 May 1979 at the
Hammarskjold Sculpture Garden, New York.
Specialists in pop-up children's books, the
New York design group Ivy Sky Rutzky worked
with Ian Hamilton Finlay in the 1970s, together
producing a small folding butterfly book, as
well as designing this concertina of tear-off
postcards for Andre.

27 Eleanor Antin, *100 Boots By the Bivouac*, 1971–73
11.5 × 17.7 cm (4 ⅝ × 7 in.)
From a set of fifty-one postcards made and mailed between 1971 and 1973, posted on 20 March 1973 in an edition of 1,000

28 Eleanor Antin, *100 Boots Go East*, 1971–73
11.5 × 17.7 cm (4 ⅝ × 7 in.)
From a set of fifty-one postcards made and mailed between 1971 and 1973, posted on 11 May 1973 in an edition of 1,000

Acknowledging the liberating influence of Fluxus on her in the late 1960s, Eleanor Antin bought a pile of surplus Wellington boots in 1970 and decided to take the photographer Philip Steinmetz on a two-and-a-half-year trek around California, documenting each of her oddly anthropomorphic placing of the boots. The photographs were printed exclusively as black-and-white postcards, which were sent by Antin and her assistants, including the writer Kathy Acker, to 1,000 art people around the world, ending up in 1973 as a solo exhibition at the Museum of Modern Art, New York. This copy of *100 Boots Go East* was dispatched by post direct from MoMA to Flash Art in Milan. Antin's work influenced her neighbour on Solana Beach, Martha Rosler, to post to friends her own series of postcard novels, *Tijuana Maid*, from 1974.

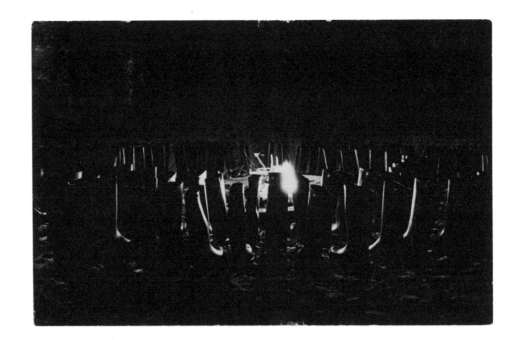

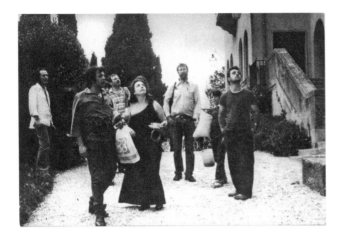

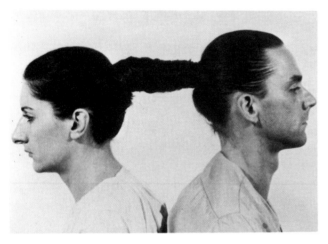

29 Charlotte Moorman, Joe Jones, Geoff Hendricks et al., *Charlotte Moorman looking up at the tower in Asolo where she will perform Mieko Shiomi's cello sonata*, 1977
10.2 × 15.2 cm (4 ⅛ × 6 in.)
Postcard published by Francesco Conz of Charlotte Moorman and others in courtyard of his house in Asolo (photographer: Gianni Bellini)

Radical elements of Fluxus were echoed during the 1960s and 1970s in the women's movement, notably by Charlotte Moorman in her organization of the Annual Avant Garde Festival of New York, founded by Moorman in 1963, persuading artists such as Yoko Ono, Alison Knowles and Carolee Schneemann to join her. In 1977 Moorman gave a performance in Italy of Mieko Shiomi's cello sonata, as shown surrounded by a group of Fluxus co-performers, from left to right: Philip Corner, Frank Pileggi, unknown, Joe Jones (behind Moorman), Geoff Hendricks, Bracken Hendricks and Brian Buczak. Bracken Hendricks, who became a leading expert on climate change, is the son of Geoff Hendricks and his wife the Fluxus artist Bici Forbes, though they were by this time separated and Hendricks was living with Buczak, the subjects together in 1978 of a renowned double portrait by Alice Neal.

30 Marina Abramović and Ulay, *performance*, 1977
10.5 × 15.0 cm (4 ¼ × 6 in.)
Postcard invitation from Association Musée d'Art Moderne, Geneva, to a performance on 8 December 1977 (front and back)

The photograph of the two artists with their long black hair tied together, back to back, was taken by Hartmut Kowalke. This is one of the earliest works of their partnership, as Marina Abramović had left her native Croatia to live and work in the Netherlands in 1976. It was there that she met the German artist Frank Uwe Laysiepen, performing under the name Ulay. The two artists worked together from 1976 to 1989. In their last piece together, titled *The Lovers*, they began walking from either end of the Great Wall of China and, on meeting in the middle, ended their personal and artistic relationship.

31 Annette Messager, *Mon Mariage*, 1975
10.0 × 15.0 cm (4 × 6 in.)
Published by Arrocaria editions, Antibes, France

The artist and critic Adrian Searle noted at Annette Messager's exhibition 'The Messengers' at the Hayward Gallery, London, in 2009 that the artist's 'preoccupation with the play and fantasies of childhood' was echoed by Susan Hiller in her postcard work (fig. 154). Messager has lived and, on occasion, worked with Christian Boltanski since the 1960s. She took the photographs of his *Comic Sketches* performances, beginning in 1974, the year Städtisches Museum Mönchengladbach published their postcard game (fig. 3) with one of these photos of Boltanski and his ventriloquist's dummy. Founded by Hervé Würz and Silke Paull in the mid 1970s, Arrocaria Editions also published postcards by Jean Le Gac, George Brecht, Duane Michals (fig. 159) and others.

32 Annette Messager, *La Femme et …*, 1975
10.0 × 15.0 cm (4 × 6 in.)
Postcard invitation to private view on 5 February 1975 at Galerie Ecart, Geneva

The titles of the works illustrated are: *Annette Messager Collectionneuse; Annette Messager Femme Pratique;* and *Annette Messager Truqueuse.* The technique in this invitation of drawing on photographs of naked women had been used in 1967 in the Flux postcard set *Monsters Are Inoffensive* (fig. 147). Since the 1970s the material of Annette Messager's work has included defaced photographs, postcards and puppets. She designed a series of graphic cards for publication at her solo exhibition 'Ouvrages' in the summer of 1988 at the contemporary art centre Le Consortium in Dijon. Groupe Ecart was co-founded in 1969 by the Swiss artist John Armleder, and their early publications included *Mail Action* (1976), with contributions by William Burroughs and an account of the trial of Genesis P-Orridge (fig.126).

33 Lynda Benglis, *Metallized Knots*, 1974
25.3 × 17.0 cm (10 × 6 ¾ in.)
Postcard announcement of exhibition from
4 to 29 May 1974 at the Paula Cooper Gallery,
New York

The colour image on this large card is of the
artist's naked back, with her jeans around her
ankles; it bears the caption on the divide of
the reverse 'Photographed by Annie Leibovitz'.
It predates the infamous dildo nude self-portrait
that Lynda Benglis placed in *Artforum* to
advertise her solo show at the Paula Cooper
Gallery in 1975. The *Metallized Knots* image
was made into a large pigment print in 1976,
in an edition of twenty-five. The image, in black
and white, had been illustrated in 1974 on the
cover of the Cologne art magazine *Extra*. For
two years between 1973 and 1974 Benglis
produced a series of works jointly with the
sculptor Robert Morris, and the *Artforum* piece
was at one time going to be a photograph of
Morris and her together naked.

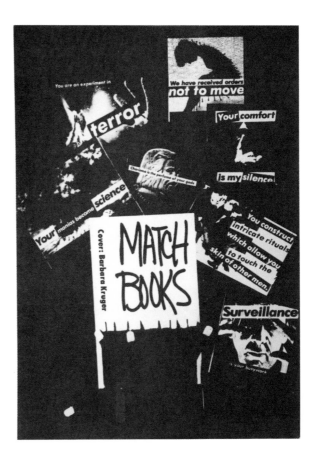

34 Rebecca Horn, *Körperraum*, 1973
14.5 × 10.5 cm (5 ¾ × 4 ¼ in.)
Postcard invitation to opening on 13 March 1973
at Galerie René Block, Berlin

This exhibition at one of Germany's leading
art galleries was Rebecca Horn's first major
solo show, concentrating, as in much of her
later work, on the bodily occupation of space.
It was followed the year after by 'Dreaming
Under Water' at the René Block Gallery in New
York. In 2001 Horn published *all these black
days – between*, a book illustrating old found
postcards. She had altered and written over the
images in various ways and mostly sent them to
the New York private art dealer Timothy Baum.

**35 Barbara Kruger, *Match Books – Fire
Sale*, 1985**
18.7 × 13.0 cm (7 ⅜ × 5 ⅛ in.)
Postcard notification of exhibition at Printed
Matter, Inc., New York

Set up in New York in 1976 by Sol LeWitt,
Lucy Lippard and others, Printed Matter, Inc.
posted this example of their sale announcement
of Barbara Kruger matchbooks to Geraldine
Malloy McGilvery, wife of the book dealer
Laurence McGilvery, in La Jolla, California.
Kruger did not turn to photography until 1979,
when she quickly developed her preference for
collaging found images, usually with polemical
capital-lettered slogans, many designed
for display as posters and postcards. She
participated, along with Hans Haacke, John
Baldessari, Barbara Bloom, General Idea and
others, in De Appel's postcard project 'Talking
Back to the Media' in Amsterdam in 1985.

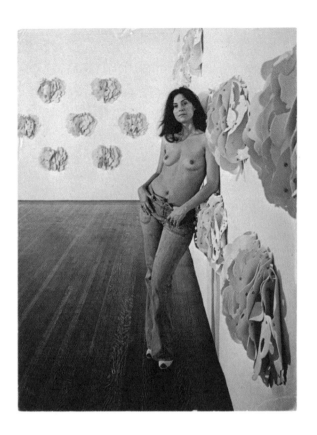

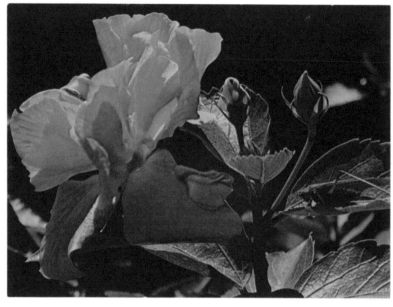

36 Hannah Wilke, *Art News Revised*,
May 1976, pp.34–35. Installation photo:
***Ponder-r-rosa Series*, 1976/1977**
16.0 × 12.0 cm (6 ⅜ × 4 ¾ in.)
Postcard published by the artist, photographed
at her exhibition in the Ronald Feldman Gallery,
New York

An active campaigner for the equal status of
women artists, Hannah Wilke used her own
body in much of her work, both in sculpture
and performance. She invented an original form
of expressing her feminist ideas by chewing
gum and moulding it into vagina-like shapes
that she applied to her naked body, and she
made vaginal sculptures from kneaded erasers
and applied them to old postcards. Suffering
from lymphoma, she recorded her illness and
its effects through *Intra-Venus*, a series of
photographs, taken by her husband. She died
in 1993 in her early fifties (fig. 143).

37 Hannah Wilke, *Gum with Grasshopper*,
1976/1977
11.6 × 15.7 cm (4 ⅝ × 6 ¼ in.)
Postcard published by the artist, from her
California series of 1976

Hannah Wilke arranged a number of small,
vulva-like sculptures on a hibiscus flower in
the garden of her elder sister Marsie Scharlatt,
photographing them to create this work
Gum with Grasshopper. It formed part of the
California series and was published by the
artist as a postcard in 1977. A fine collection of
Wilke's postcard pieces is held by the Hannah
Wilke Collection & Archive in Los Angeles.

38 Claes Oldenburg, *The Knees Monument: 'Noon'*, 1966

13.0 × 20.0 cm (5 ⅛ × 7 ⅞ in.)
Self-published postcard with printed inscription on the reverse: 'A colossal monument to be erected on the Victoria Embankment. POST CARD. Printed in Great Britain'

The postcard image is taken from Claes Oldenburg's collage showing the pink legs of his then partner Hannah Wilke, similar in form to his *London Knees* sculpture of the same year. The three related postcards, *Dawn*, *Noon* and *Sunset*, were published by Editions Alecto Ltd in 1966, in a boxed edition containing latex sculptures and other items. Remembering this period of work, Oldenburg wrote in *The Multiples Store* (1996): 'It is difficult now to imagine how revolutionary this paradoxical combination of masculine voyeurism and feminine liberation seemed in its time…The architectural and fetishistic functions of knees were accentuated by the fashion of wearing boots with the mini, which created a sharply demarcated area of the body suitable for objectification.'[22]

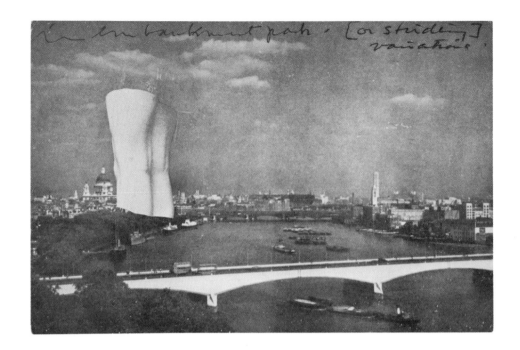

39 Vito Acconci, *Applications*, 1970/1971

10.5 × 15.0 cm (4 ¼ × 6 in.)
Postcard announcement of exhibition from 27 March to 24 April 1971 at John Gibson Gallery, New York

For this second exhibition of the video *Applications*, the invitation shows a woman applying lipstick kisses to the artist's bare chest. In an interview with Robin White for *View* published in 1979, Acconci spoke directly about the making of his earlier works: 'Those pieces using my own body in '70 started from thinking "What – how can I think of a generalized art condition?" It seems like in any kind of art situation, the viewer…is treating artwork as a kind of target…So, could I use this target-making activity as a condition of art-going? In other words, could I treat myself as a target, then, in turn, this target-making activity is made available for viewers?'[23]

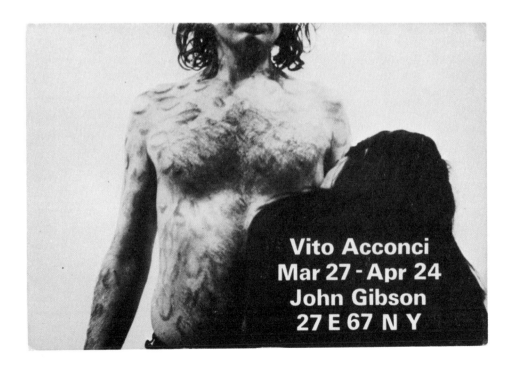

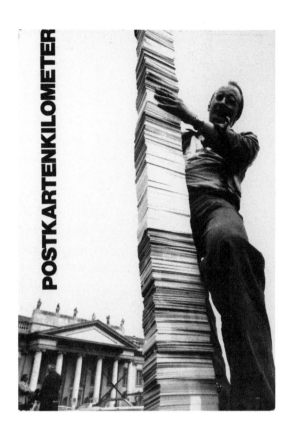

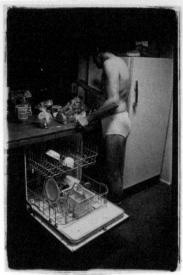

40 Klaus Staeck, *Postkarten Kilometre*, 1977
14.5 × 10.5 cm (5 ¾ × 4 ¼ in.)
Postcard published by Tage for 'documenta 6', captioned on the reverse: '1 km Postkarten. Fromage à Walter de Maria'

Klaus Staeck has issued new postcards to his own design every year since 1968. They are invariably provocative, combining pictures and text, and many are by his artist friends, more by Joseph Beuys than anyone else. Staeck powerfully expresses his artistic aims: 'With my work I would like to contribute towards exposing the untruthfulness of the excess of pictures surrounding us – I should like not to present what has been exposed, but to expose what has been presented.'[17] An example is his 1985 publication of Nam June Paik's postcard *20 Juli*, the date of Paik's birth. In 2006 Staeck, a committed critic of the status quo, was elected president of the Akademie der Künste, Berlin.

41 Allan Kaprow and Vaughan Rachel, *Desert Hot Springs*, 1978
10.5 × 15.0 cm (4 ¼ × 6 in.)
Photographic postcard of Allan Kaprow taken by his then wife Vaughan Rachel, published privately by her at Eagle Rock, California

The photographer Vaughan Rachel was a founding member of the Pasadena Women's Political Caucus, before marrying Allan Kaprow in 1955, shortly before he was creating his first Happenings, which strongly influenced the foundation of Fluxus in the 1960s. Kaprow wrote in an untitled essay of 1958, published in 1966 as a Great Bear pamphlet by Something Else Press: 'I am ruthlessly impatient with anything I seriously attempt which does not shriek violently out of the unknown present, which does not proclaim clearly its modernity as its raison d'être.'[18] Kaprow was quoted by Rose Lee Goldberg in her book *Performance* (1979) as saying: 'The term "happening" was meaningless; it was intended to indicate something that just happens to happen.'[19]

42 Bruce Nauman, *Self-portrait as a fountain (2)*, 1968
17.8 × 22.1 cm (7 ⅛ × 8 ¾ in.)
Jumbo Post Card published by Leo Castelli as an invitation to his Bruce Nauman show in 1968

The postcard invitation publishes for the first time in black and white Bruce Nauman's colour photograph *Self-Portrait as a Fountain* from 1966. It was published between 1966 and 1970 and forms part of the series *Eleven Colour Photographs*. Designed by Marcus Ratliff for the Leo Castelli Gallery on East 77th Street, New York, the back of this Jumbo Post Card is in the conventional postcard format, including a stamp square, with a short invitation message printed as if written in biro, in sloping capital letters.

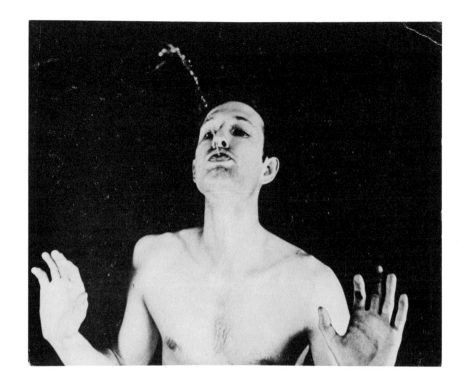

43 Bruce Nauman, *Body (documentation)*, 1971
15.0 × 16.7 cm (6 × 6 ⅝ in.)
Postcard invitation to exhibition at John Gibson Gallery, New York, and notification of *Body (performances and films)* at New York University, also in February 1971

In this group show of work by Vito Acconci, Dan Graham, Richard Serra, Michael Snow and Bruce Nauman, the piece chosen for illustration on the postcard invitation is a work by Nauman. Showing the artist pulling his mouth into an odd shape, it was taken from his first series of screen prints *Studies for Holograms*, published in 1970 by Leo Castelli. It documents his performance piece 'about the body as something you manipulate'.

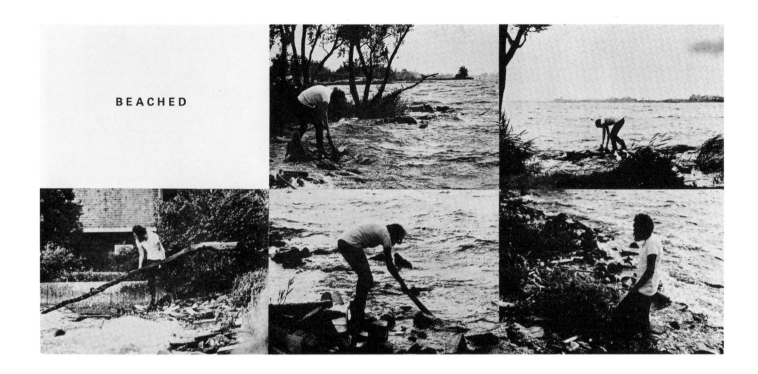

BEACHED

44 Lawrence Weiner, *Beached*, 1970
14.0 × 30.0 cm (5 ⅝ × 11 ⅞ in.)
Postcard invitation from Fernsehgalerie Gerry
Schum, Hanover, to the screening of video
sculpture in October 1970 at Konrad Fischer's
stand at the 'Kölner Kunstmarkt' fair in Cologne

The reverse states: 'On 16 August 1970
in Holland Lawrence Weiner built five
examples of *Beached*. Each of these five
visual informations is made in an edition of
one.… Lawrence Weiner chooses not to sign
informations or works.' Weiner, who was still
in his twenties at the time these sculptural
videos were made, registers his refusal to
accept the art-world status quo by naming
the category of work 'informations' and by
declining to supply a signature. The video
shows him fishing driftwood out of the water
in five different ways and placing it on the
beach. Weiner announces on the soundtrack
that: '*Beached* is a public freehold example
of what could be art within my responsibility,
as the artist may construct the work, &/or the
work may be fabricated, &/or the work need
not be built, all being equal and consistent
with my intentions. I elected to construct five
material possibilities for videotape.'

45 Dennis Oppenheim, *Below Zero Snow Projects*, 1969
10.5 × 15.0 cm (4 ¼ × 6 in.)
Postcard announcement of exhibition at John Gibson Gallery, New York

In the early 1970s Dennis Oppenheim executed a series of works using his own body, the earliest exhibited in the group show 'Body Works' in 1970, which included getting partly sunburnt, in the belief that working with the land 'demands an echo from the artist's body'. The postcard invitation to his show 'Material Interchange for Joe Stranad' (1971) at Galleria Françoise Lambert, Milan, illustrated a mosquito, noting on the reverse, from an interview with the *Avalanche* editor Willoughby Sharp: 'In Aspen in 1970 I captured a female mosquito, placed it inside a glass jar and laid it over the forearm of Joe Stranad, a friend. It eventually bit him'.[24] producing the kind of physical echo the artist liked.

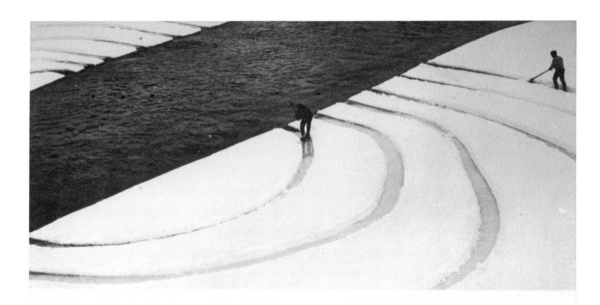

Below Zero Snow Projects Dennis Oppenheim
Opens Saturday January 11 — thru February 14
John Gibson 27 East 67th Street New York

On May 9 (friday), May 12 (monday) and May 30 (friday) 1969 at 3:00 Greenwich Mean Time (9:00 EST) Jan Dibbets will make the gesture indicated on the overside at the place marked "X" in Amsterdam, Holland.

Le 9 May (vendredi), le 12 May (lundi), le 30 May (vendredi) 1969 à 3:00 heures di l'aprés-midi GMT, Jan Dibbets fera le geste comme indiqué à ce verso à l'endroit marqué "X" à Amsterdam, Pays Bas.

Am 9 Mai (Freitag), 12 Mai (Montag) und 30 Mai (Freitag) 1969 um 3:00 Nachmittags (GMT), Jan Dibbets wird das Gebärde wie am anderen Seite machen auf der mit einem "X" bezeichneten Stelle in Amsterdam, Holland.

Op 9 mei (vrijdag), 12 mei (maandag) en 30 mei (vrijdag) 1969 om 3:00 uur 's middags (GMT), zal Jan Dibbets het gebaar, zoals op de andere kant van deze kaart, maken op de met een "X" gemarkeerde plek in Amsterdam, Nederland.

SETH SIEGELAUB NEW YORK

46 Jan Dibbets, *Untitled*, **1969**
10.1 × 15.0 cm (4 × 6 in.)
Postcard published by Seth Siegelaub

Jan Dibbets made this postcard piece in 1969, at the age of twenty-eight. It was published in New York by the influential curator Seth Siegelaub, with a caption on the back of the card in English, French, German and Dutch. This postcard was part of the show 'Exhibition by Mail' (1969) presented by Siegelaub from New York. Dibbets had explored the idea of an exhibition without an end object in a show in Frankfurt in 1967 with, among others, Richard Long and Barry Flanagan, when between 7.55 and 9.55 p.m. the artists worked with water, sand and air, at the end of which no object of substance remained. Siegelaub had opened a gallery in his home city of New York in 1964, closing the space eighteen months later to concentrate on less conventional forms of art-action, initially representing the young conceptual artists Robert Barry, Douglas Huebler, Joseph Kosuth and Lawrence Weiner (fig. 44). In the early 1970s, Siegelaub dedicated a great deal of his time to the definition and legal registration of The Artist's Reserved Rights Transfer and Sales Agreement, moving to live in Paris in 1972 and to Amsterdam in 1990.

47 Jan Dibbets, *TV as a Fireplace*, 1969
14.5 × 21.0 cm (5 ¾ × 8 ⅜ in.)
Postcard invitation from Fernsehgalerie Gerry
Schum, Hanover, to video transmission from
24 to 31 December 1969 at Westdeutsches
Fernsehen

At the Fernsehgalerie Jan Dibbets's television
fire was shown on screen for three minutes
every day for a week. In 1970 Schum shot a
Dibbets video in two parts, *Painting 1 & 2*, the
postcard invitation with a still of the artist's red
lower legs in a green field. Dibbets told the
Stedelijk Museum, Amsterdam, on the occasion
of their 1980 exhibition on Schum's video
project that he had been drawn 'to the integrity
of Schum's ideas'.

48 Jan Dibbets and Reiner Ruthenbeck,
***Untitled*, 1969**
10.5 × 21.0 cm (4 ¼ × 8 ⅜ in.)
Postcard announcement by Konrad Fischer
Galerie, Düsseldorf

The grid of four images of the artists is
captioned, in German and English: 'The
energy of a real English breakfast transformed
into breaking a real steel bar by the artists
Dibbets and Ruthenbeck.' Three of the four
photographs were taken outside the Institute
of Contemporary Arts, London, at its current
home in the Mall, less than a year after it moved
from its original premises in Dover Street.
Until he took the radical step of embracing
film in late 1968, Jan Dibbets was primarily
a painter, though he later turned towards
still photography. Apart from the occasional
video performance, Reiner Ruthenbeck has
concentrated on sculpture, as seen in his
solo show at the Serpentine Gallery, London,
which opened in November 2014.

DIE ENERGIE EINES ENGLISCHEN FRÜHSTÜCKS UMGESETZT IN DAS
BRECHEN EINES STAHLDRAHTES DURCH DIE KÜNSTLER DIBBETS
UND RUTHENBECK

LONDON, AUGUST 1969

THE ENERGY OF A REAL ENGLISH BREAKFAST TRANSFORMED INTO
BREAKING A REAL STEEL BAR BY THE ARTISTS DIBBETS AND
RUTHENBECK

LONDON, AUGUST 1969

CROSSING PLACE

TWO WALKS BY ROADS AND LANES
FOLLOWING TWO IMAGINARY STRAIGHT LINES

A WALK BY ALL ROADS AND LANES
TOUCHING OR CROSSING AN IMAGINARY CIRCLE

A 24 HOUR WALK

THROWING A STONE AROUND MCGILLYCUDDY'S REEKS

SLEEP

A WALK TO THE SUMMIT OF POPOCATEPETL MEXICO JANUARY 1990 ONE NIGHT BIVOUAC ON THE CRATER RIM

A WALK TO THE SUMMIT OF PICO DE ORIZABA MEXICO NOVEMBER 1979 ONE NIGHT BIVOUAC ON THE CRATER RIM

49 Richard Long, *Crossing Place*, 1977
10.0 × 15.2 cm (4 × 6 in.)
Graphic offset lithograph invitation to solo
exhibition from 21 May to 18 June 1977
at Lisson Gallery, London

50 Hamish Fulton, *Sleep*, 1991
10.5 × 15.0 cm (4 ¼ × 6 in.)
Postcard invitation to opening on 1 March 1991
at Galerie Tanit, Cologne

Both Richard Long and Hamish Fulton began
to use walking as an art form while at Saint
Martin's School of Art in the mid-1960s.
The two artists, who are friends, have over the
years undertaken eleven long walking projects
together, making their own different artwork
along the way. They each take considerable
care over the typography and design of their
exhibition invitations, postcards and books,
which are the main form, in many instances,
of communicating the nature of their forages
into distant territories.

51 John Baldessari, *I too have sinned*, 1979
10.5 × 15.0 cm (4 ¼ × 6 in.)
From complete set of *Mèla Post Card Book*
by forty-eight artists, published by Maurizio
Nannucci and printed by Biancoenero, Florence,
in an edition of 1,000

52 John Cage, *Il treno di John Cage*, 1979
15.0 × 10.5 cm (6 × 4 ¼ in.)
From complete set of *Mèla Post Card Book*
by forty-eight artists, published by Maurizio
Nannucci and printed by Biancoenero, Florence,
in an edition of 1,000

In 1976 Maurizio Nannucci founded the
newspaper Mèla, its last issue published
in 1981, and this gathering of postcards
by numerous major art figures relates
to contributions to this publication. The
postcards are all ascribed and titled,
including: Chris Burden, *Kunst Kick*; James
Lee Byars, *Postcard*; Robert Filliou, *Works
at Play at the Icelandic School of Art*; Sol
LeWitt, *Arcs & Lines Lines & Lines*; Maurizio
Nannucci, *falso/vero*; and Edward Ruscha,
1978. Since the mid-1960s Nannucci has
been a pioneering figure in the artistic use
of postcards, both as exhibition invitations
and in mail art, a commitment that continues
today. He was influential in the development
of mail art behind the Iron Curtain, where the
confiscation of material, including postcards
sent and received, limited the scope of artistic
expression. The large show 'Postcards &
Artist Cards. A documentation of cultural
history. Gallery Arcade. State art trade of the
GDR' in November 1978 was a breakthrough,
including the publication of handmade and
signed postcard art in a limited edition of thirty.
The sixteen exhibitors included Joseph Beuys,
Guglielmo Achille Cavellini (fig. 145) and Klaus
Staeck from the West, and his brother Rolf
Staeck and the concrete poet Robert Rehfeldt,
both from the GDR.

I TOO HAVE SINNED.

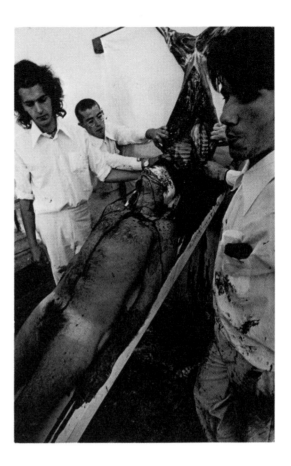

53 Chris Burden, *Big Wrench*, 1979
14.5 × 9.6 cm (5 ¾ × 3 ⅞ in.)
Postcard announcing live broadcast of a
performance produced by La Mamelle Inc.,
San Francisco

This performance by Chris Burden was
broadcast live on Channel 26 KTSF-TV, San
Francisco, on 5 November 1979 and made by
the artist the next year into a video. La Mamelle
was a not-for-profit arts organization active in
the San Francisco Bay Area from 1975
to 1995.

**54 Hermann Nitsch, *Om Theater Nitsch*,
1975/1977**
15.2 × 9.8 cm (6 × 3 ⅞ in.)
Postcard from boxed set of 1977 published
by Image Bank in an edition of c. 750

In the early 1960s the radical Viennese
performance artist Hermann Nitsch was
occasionally involved in Fluxus activities. He
introduced Francesco Conz to the musical
experimentalist Joe Jones, thus making possible
decades of Fluxus publications in Italy. Nitsch
had a holiday studio in Asolo, in the Veneto,
where Conz lived in the 1970s, publishing
screen prints from drawings by Nitsch, a set
of which is in the Tate collection. In 1966
Nitsch visited London to participate in Gustav
Metzger's Destruction in Art Symposium.
Twelve years later he gave his first performance
piece in Los Angeles, *Orgies Mysteries Theatre*.

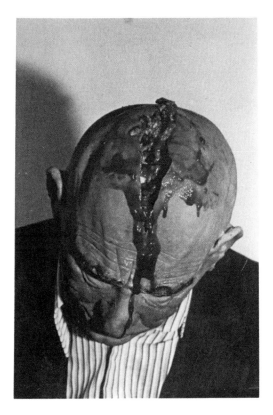

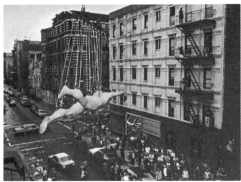

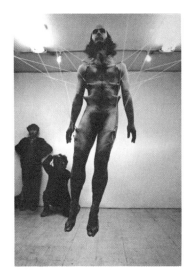

55 Paul McCarthy, *Hollywood Halloween*, 1977/1978

15.5 × 10.5 cm (6 ⅛ × 4 ¼ in.)
Postcard printed for the artist from a photograph by Ronald Benom with details on reverse printed from rubber stamps

Paul McCarthy's piece *Hollywood Halloween*, a set of nine silver gelatin photographs of a performance work, was made in 1977 in an edition of three. The next year the artist published for his own use five different postcards, based on the earlier work but all the photographs close-cropped and some, including this example, of images not previously used.

56 Stelarc, *Performances*, 1976–84

10.5 × 15.0 cm (4 ¼ × 6 in.) and
15.0 × 10.0 cm (6 × 4 in.)
Two from a group of twenty-six postcards illustrating, above, *Street Suspension*, 604 E. 11th Street, New York, 21 July 1984 (photographer: Nina Kuo) and, above right, *Event for Lateral Suspension*, Tamura Gallery, Tokyo, 12 March 1978 (photographer: Anthony Figallo)

Born in Cyprus in 1946, Stelios Arcadiou grew up in Melbourne, Australia, changing his name in 1972 to Stelarc. He specialized in extreme performances, in which he was suspended from flesh hooks. Later he went further, adding prosthetic limbs and electronic stimulus, as well as surgically constructing and stem-cell growing an ear on his arm with the intent of electronically augmenting and internet-enabling the ear as a remote listening device for people in other places. Stelarc's preferred method of documenting and promoting his work was through postcards. The latest record in this group was of him hanging high above E. 11th Street, New York, on 21 July 1984. His final flesh-hung performance, *Ear on Arm Suspension*, was realized in 2012, at the age of sixty-six.

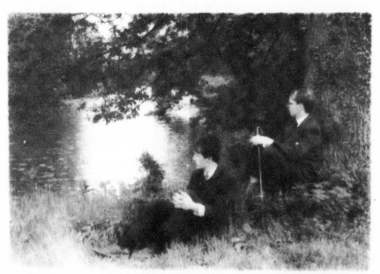

'Here in the country's heart where the grass is green life is the
same sweet life as it ere hath been.' Gilbert & George
THE SCULPTORS

Gentlemen.....

57 Gilbert & George, *The Nature of Our Looking*, 1970
10.5 × 15.0 cm (4 ¼ × 6 in.)
Postcard invitation to a private view from 13 to
18 October 1970 at Konrad Fischer in Cologne,
in partnership with Gerry Schum

This early work is Gilbert & George's first video
piece, lasting eight minutes and published in an
edition of four by Gerry Schum's Videogalerie.
The image on the postcard is a still from the
film, shot in Sussex. It was at this Fischer
exhibition that Gilbert & George met Gerhard
Richter, commissioning him to paint a portrait
of them on the occasion of their 1974 show
with Fischer. Richter ended up making eight
different portraits of Gilbert & George, painted
from amalgamated and overlapping photos,
all of which he exhibited in his solo show at
Konrad Fischer's in 1975.

58 Gilbert & George, *Gentlemen…*, 1972
14.0 × 9.0 cm (5 ⅝ × 3 ⅝ in.)
Front of postcard printed by the artists as Art for
All at 12 Fournier Street, London, in spring 1972

The artists published this postcard alongside
its pair *Human Sculpture* (1972), signed in
brown ink by both artists and self-published
under the title *Art for All* from their home in
Fournier Street, Spitalfields, London, as it still is
today, approaching fifty years later. For reasons
of economy as well as aesthetic preference,
several of Gilbert & George's student and early
professional works involved postcards. In 1969
they arranged for their Saint Martin's colleague
Bruce McLean to present a series of public
lectures at the Hanover Grand banqueting hall,
acting out postcard scenes of artworks.

59 Gilbert & George, *Gentlemen…*, 1972
14.0 × 9.0 cm (5 ⅝ × 3 ⅝ in.)
Back of postcard printed by the artists as Art for
All at 12 Fournier Street, London, in spring 1972

This example was mailed to Anthony de Kerdrel,
a luxury yacht broker. Sol LeWitt also owned a
copy, sent to him at the time by the artists and
exhibited in 'No Title', the show of LeWitt's art
collection at the Wesleyan University in 1981.

60 Gilbert & George, Keith Arnatt, Richard Long, Hamish Fulton, Art & Language, Barry Flanagan and others, *The New Art*, 1972
11.7 × 18.0 cm (4 ⅝ × 7 ⅛ in.)
Postcard announcement by the Arts Council of Great Britain of the exhibition 'The New Art' at the Hayward Gallery, London, from 17 August to 24 September 1972

As a number of the artists in this significant exhibition had been students together at Saint Martin's School of Art, London, in the mid-1960s, the Arts Council decided to illustrate one of this group's works on the postcard invitation, choosing Gilbert & George's *Photo-pieces* (1971). Throughout the year the artist duo had exhibited various asymmetric combinations of these photographs, differently framed and sized, including at the Konrad Fischer Galerie in Düsseldorf. In 1973 these photographic compositions become unified, and by 1974 flush-grid framing had emerged, a format Gilbert & George continue to use today in their large photo-pieces.

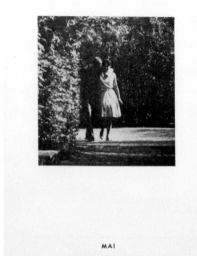

MAI

JUNI

AUGUST

61 Hans-Peter Feldmann, *12 Postkarten*, 1974

15.0 × 10.5 cm (6 × 4 ¼ in.)
From set of eleven postcards taken from found material, issued by the artist through Galerie Paul Maenz in Cologne

In this project Hans-Peter Feldmann mailed to chosen people a postcard made by him from a found image. He posted it at the beginning of each month for eleven months of the year, always leaving out, at random, one month's postcard to prevent any individual acquiring the complete set. In this example, the deliberately missing card is *Juli*. The postcard images were taken from a calendar found by the artist in a naturist's tent. In 1980 Feldmann took the radical step of rejecting the entire art world, claiming that he had destroyed all his work to date. Invited to contribute in 1995 to the Serpentine Gallery group exhibition 'Take Me (I'm Yours)' in London, he recanted and has since shown many works, a number of which use found images.

Opposite
62 Endre Tót, *One Dozen Rain Postcards*, 1971–73

15.0 × 10.5 cm (6 × 4 ¼ in.)
Complete set of twelve postcards published by Reflection Press

The postcards were made from manipulated Xerox copies printed in purple, published in an envelope bearing the Hungarian Endre Tót's coloured rubber stamps, in green, red and purple. The titles and dashes of rain and zeros were typed by Tót on to the Xeroxes prior to printing as postcards. The twelfth card is a smiling image of the artist, stating his pleasure in making these rain works. *One Dozen Rain Postcards* was first publicly exhibited at Galerie Ecart, Geneva, in 1974, together with several unique postcard pieces and small books that Tót had created around rain.

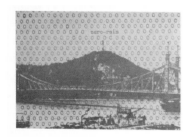

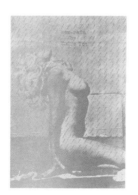

2. Graphic Postcards

The leaders of a British revival in artist-run presses, producing postcards, poetry booklets and pamphlets as and when the desire struck, were Ian Hamilton Finlay (fig. 73) at his Wild Hawthorn Press in the Pentland Hills outside Edinburgh, Stuart Mills (fig. 74) at his Tarasque Press in Nottingham, and Simon Cutts (fig. 67) at Coracle, previously based in London but now operating from Clonmel, Ireland.

Cutts wrote in *Some Forms of Availability* (2007) of his own and Finlay's private press journey as 'a kind of minefield of perseverance and trying to sustain a sense of the optimistic modern work in a sea of desperate fallout.'[25] Of enduring appeal among Finlay's postcards are those he periodically made in irreverent comment on dead artists, such as *Homage to Kandinsky* (1971), *Homage to Pop Art* (1973; fig. 72) and *Homage to Seurat* (1972), the last in the form of a dot-to-dot puzzle which, when filled in, pictured his own model boats on the pond in his garden in a similar composition to Seurat paintings of sailing boats in seaside bays.

Several American conceptual artists have also made graphic use of the postcard in their work. Sol LeWitt used stylized representations of his geometric wall drawings for postcard invitations, versions of which appeared in the personal postcards he sent (fig. 64). LeWitt's artist-friend John Baldessari (fig. 51) wrote in *Wall Drawing* (1981): 'Sol is gentle with the wall, lets it speak.'[26] In an issue of *Art-Rite* (1973–78) Baldessari expressed his pleasure in the accessible publication of invitations, postcards and books: 'since a lot of people own the book, nobody owns it. Every artist should have a cheap line. It keeps art ordinary and away from being overblown.'[27] Teaching at Cal Arts from its inception in 1970, both Baldessari and his colleague Doug Huebler encouraged a radical approach to the arts, as did Nam June Paik at the film school.

The Japanese artist On Kawara made several ritualized series of artworks, one of the most rigorous being the *I GOT UP* postcards that he sent to two recipients every day for twelve years, between his arrival in Mexico City in 1968 (fig. 63) and the theft of his rubber stamp in Sweden in 1979. All the postcards are similar in style and content, with the stamped information on the message side of a local tourist postcard.

Regular recipients of *I GOT UP* postcards included John Baldessari, Angela Westwater and Seth Siegelaub, all three of whom received postcards daily for several months, in blocks of work now belonging to major museums. Nicholas Logsdail, founder of the Lisson Gallery, London, who met Kawara in 1970 and put on solo shows of his work in London in 1978, 1985 and 1992, recently emailed: 'I have treasured these postcards not only as a symbol of friendship and recognition from On, but also one of the most profoundly simple, personal and professional communications I had from any of the artists during this formative period.'[28]

Radical social and conceptual developments in graphic artwork in the 1960s and 1970s were often conveyed in postcards. For the solo Carl Andre show at the Solomon R. Guggenheim Museum, New York, in 1970, the art historian Diane Waldman wrote: 'Andre's formidable accomplishments occurred in the middle '60s, a time which had not yet begun to question the validity of either the object per se or the social media.'[29] The backs of invitation postcards can be as informative about the aesthetic characteristics of the period as the fronts: other examples of two large announcement cards of 1966 in the collection, illustrating works by Andy Warhol (fig. 81) and Louise Nevelson, are both now in the Museum of Modern Art, New York, and display similarly distinctive slanted lettering.

Today, when dominant sections of the art world have reverted to worship of record auction prices, artists who make postcards have been keen to preserve conceptual rigour. Peter Liversidge (fig. 68) placed words on invitation postcards to his exhibitions at Matt's Gallery, London, and also, in 2013, on a set of postcards for the Edinburgh Festival. Known primarily for his high-priced paintings, Peter Doig was involved with events organized in the 1990s by Imprint 93, including his design of a conceptualist postcard (fig. 69), revealing another side of his creativity. Exhibitions showing the free distributions of complete runs by Imprint 93 have been mounted recently at the Whitechapel Gallery, London, and Printed Matter, Inc., New York.

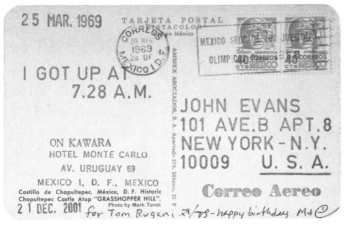

63 On Kawara, *I GOT UP*, 1969
8.5 × 13.8 cm (3 ⅜ × 5½ in.)
Rubber-stamped commercial postcard sent by
On Kawara to John Evans in New York from
Hotel Monte Carlo, Mexico City, on 25 May
1969, with, on the front, Chapultepec Castle

This work from On Kawara's *I GOT UP* series
is among his earliest, made a few months after
his arrival in Mexico City. Always choosing local
tourist postcards, Kawara addressed them all
in similar style, revealing an equally disciplined
approach to his date paintings, made between
1966 and 2013. The artist John Evans lived
at the same New York address from the early
1960s until his death in 2012. With a ritual
rigour similar to his friend Kawara, Evans made
a collage in a series of notebooks every day
from 1964 until choosing to stop in 2000,
at the new millennium.

64 Sol LeWitt, *Postcard*, 1974
10.5 × 15 cm (4 ⅛ × 5 ⅞ in.)
Postcard sent from New York on 1 January 1974
to Doug Debber in Venice, California, by Sol LeWitt
with New Year message and grid drawing in pen

Sol LeWitt regularly sent commercial postcards
to friends, with grid drawings on the back
signed 'Sol', as in this example, or 'SL'.
The ironic choice of image is a Dutch colour
postcard of three Canadian jet fighters flying in
formation. The printed caption on the reverse
of the card details information on the Northrop
NF-5B planes. Doug Debber, a painter and art
teacher, has lived in California since 1965 and
continues to participate in the Venice art scene.

ONE LINE FROM THE MIDDLE OF THE LEFT SIDE TOWARD THE LOWER RIGHT CORNER. SOL LEWITT, NEW YORK 7/12/73

65 Sol LeWitt, *Postcard*, **1977**
9.8 × 15.2 cm (3 ⅞ × 6 in.)
Designed specifically as a postcard to be published in 1977 by Image Bank, Vancouver, as part of a boxed set in an edition of *c.* 750

Sol LeWitt was a leading figure in the visual application of words to art, writing in *Sentences on Conceptual Art* (1969): 'If words are used, and they proceed from ideas about art, then they are art and not literature.'[30] Like his friends Carl Andre and Lawrence Weiner, LeWitt designed most of his own postcard invitations, including *The Location of Lines* (1973) at the Lisson Gallery, London, *Lines from our sides of four walls* (1975) at the Konrad Fischer Galerie and *Structuren* (1984) at the Stedelijk van Abbemuseum, Eindhoven.

66 Roy Lichtenstein, *Drawings*, **1972**
18.0 × 25.5 cm (7 ⅛ × 10 ⅛ in.)
Large invitation postcard to exhibition from 22 January to 12 February at Leo Castelli, New York

Drawings and paintings of classical ornamental vocabulary by Roy Lichtenstein were subsequently made into a series of prints combining screen print, lithography and embossing titled *Entablatures* (1974–76). Lichtenstein contributed a folded boat hat in a colourful screen print to *SMS portfolio, No. 4* in 1968, the same year as Richard Hamilton's *To Mother* (see fig. 6) for *SMS No. 1*. Later, Simon Cutts floated on his friend John Bevis's pond in Norwood one of the boat hats, to photograph it and make into a postcard for the cover of his Crafts Council catalogue *The Artist Publisher* (1986).

67 Simon Cutts, *was the Nativity a site-specific installation?*, c. 1996

11.0 × 15.0 cm (4 ⅜ × 6 in.)
Postcard published by Simon Cutts at
workfortheeyetodo, 51 Hanbury Street,
Brick Lane, London

Simon Cutts defies conventional definition,
his poetry both concrete and lyrical, his printing
at Coracle at once traditional and progressive.
Cutts wrote in his collection of essays *Some
Forms of Availability* (2007): 'The postcard
has always been one of the most available
of formats, its ease of production, its self-
circulation, its accidental discovery.'[31]
A graphic card by Cutts has been co-opted,
with his approval, as the title of this book, part
of a series that began with *No Free Reading*
(1996) and includes *The Postcard Is a Public
Work of Art* (1996), *The World Has Been
Empty Since the Postcard* (2015) and *The
Postcard Is Always Innocent* (2017).

68 Peter Liversidge, *In the bleak mid-winter months very little stirs on the North Montana Plains*, 2000

10.0 × 15.8 cm (4 × 6¼ in.)
Self-published postcard in an edition of forty-five

Peter Liversidge's postcards are striking,
with their simple lettering and clean lines.
He produced three different postcards in this
North Montana series, each of them printed on
thick white paper, using a traditional letterpress
technique. Liversidge studied at Montana State
University between 1994 and 1995, the origin
of references in this subsequent work.

* was the Nativity a site - specific installation ?

In the bleak mid - winter months
very little stirs on the
North Montana Plains

There's a painting on the wall.

Art isn't working.

69 Peter Doig and Matthew Higgs,
There's a painting on the wall, **1996**
10.5 × 15.0 cm (4¼ × 6 in.)
Postcard invitation to a project at Anthony
Wilkinson Fine Art in Great Ormond Street,
London, from 18 March to 13 April 1996,
an Imprint 93 event in an edition of *c.* 180

Imprint 93 operated in London from 1993
to 1998. It was founded by Matthew Higgs,
presently director of the not-for-profit White
Columns gallery in New York, set up in 1970
by Gordon Matta-Clark and Jeffrey Lew as an
alternative arts space. Higgs's mimeographed
announcements were posted out free to a brief
list of regular recipients. The painter Peter Doig
hosted several of their Weekender events at
his King's Cross studio. This is one of the few
postcards that Higgs made at Imprint 93, whose
other participants included Fiona Banner (fig.
167), Jeremy Deller (fig. 176), Paul Noble and
Alan Kane (fig. 182).

70 John Bevis, *Art isn't working – A*
postcard from the Saatchi Collection, **1995**
10.5 × 15.0 cm (4¼ × 6 in.)
Correspondence Series No. 4 published by John
Bevis at Coalport Press, Shropshire, and posted
by him to friend and fellow artist Les Coleman

John Bevis was co-founder of Chocolate
News Books in the 1980s with Colin Sackett
when both were working for Simon Cutts at
Coracle in London. They were also friends
of fellow postcard makers/publishers Les
Coleman and Ian Hamilton Finlay. A poet,
Bevis gives readings of his work and issues
postcards and small publications, printed by
various people for his one-man Coalport Press.

71 Augusto de Campos, Ian Hamilton Finlay, Eugen Gomringer, José Lino Grünewald, Dom Sylvester Houdédard and Gerhard Rühm, *Six Concrete Poems*, 1967
16.5 × 11.5 cm (6½ × 4⅝ in.)
Complete set of six postcards commissioned by Stephen Bann for the 1967 Brighton Festival and printed in the School of Graphics at Chelsea School of Art, London

This letterpress printing of concrete poems specifically for postcards contains typical work by two of the British leaders in the field, Dom Sylvester Houdédard and Ian Hamilton Finlay. *Star* was the first full-scale design for a postcard by Finlay, who wrote of this work to Bann: 'I wanted just a simple, unclever star, made with simple straight lines…I mean, how vulgar people are, always wanting you to be clever and not seeing how far one could go to avoid exactly that, at certain points in one's work…Clever – how easy.'[32]

HOMAGE TO POP ART

'Treat Nature as the Cube, the Cone, and the Slider'

TROMBONE CARRIER

72 Ian Hamilton Finlay, *Homage to Pop Art*, 1973
10.5 × 15.0 cm (4¼ × 6 in.)
Made with the assistance of Sydney McK. Glen at Finlay's Wild Hawthorn Press in an edition of *c.* 250

73 Ian Hamilton Finlay, *Trombone Carrier*, 1975
10.5 × 15.0 cm (4¼ × 6 in.)
Screen-printed card with three paperclips published by Finlay's Wild Hawthorn Press

Ian Hamilton Finlay regularly designed and made postcards to communicate his passionately held convictions. Wild Hawthorn Press, which Finlay founded in 1961, published over 700 of his postcards and folded cards, many of which the press still sells today in the original edition. Postcards were his form of contact with the outside world for, following his breakdown in 1954, when he was hospitalized, Finlay developed agoraphobia and seldom travelled far from his home near Edinburgh. His printed work was nevertheless internationally influential, praised by the garden historian Dr Patrick Eyres in 1984 in the *New Arcadian Journal*, no. 15, for 'the quality of production embodied in the private presses…a further dimension added by their criteria which necessitates postal works: either specifically designed as such or to be readily despatched and accessible through the post'. Despite ill health, Finlay was determinedly combative, conducting with Strathclyde Council a long battle around planning designation of the temple that he built in his garden, referred to by Finlay and his supporters as the Little Spartan War, their argument expressed in a sheaf of neo-classical postcards. *The Guardian* art critic Waldemar Januszczak was another Finlay target, including publication in 1986 at Wild Hawthorn Press of a folder of sixteen small cards titled *Thoughts on Waldemar*, No. 7 of which reads 'His arrogance lacked bevel.'

74 Stuart Mills, *Homage to Wyndham Lewis*, 1969
10.0 × 15.0 cm (4 × 6 in.)
Postcard published by the artist's Tarasque Press
in Nottingham

Postcards are eminently suited to the
expression of concrete poetry, where visual and
verbal elements coalesce. Stuart Mills founded
the Tarasque Press in Nottingham in 1964.
One of his earliest assistants was Simon Cutts,
with whom he set up the magazine *Tarasque*
and ran the Trent Bookshop. The magazine
ceased publication in 1971 and the bookshop
went bankrupt the following year. In a pamphlet
produced by the University of Warwick for an
exhibition about Moschatel Press in 1982, Mills
wrote that 'the Concrete Poetry movement…
moved away from the tradition of oral poetry in
the belief that the poem was as much object as
it was song'.[33]

Homage to Wyndham Lewis

75 Henri Chopin, *Vibrations*, 1986
10.5 × 15.0 cm (4¼ × 6 in.)
Postcard invitation to a private view
on 1 February 1986 to solo exhibition
'Typewriterpoems' at Edition Hundertmark
in Cologne

Henri Chopin was a leading figure in sound
poetry and concrete poetry, both interests
expressed in his design for this invitation
postcard. In 1964 Chopin had launched, with
the assistance of his wife, the English-born
academic Jean Ratcliffe, the review-disc *OU/
Cinquième Saison*, which he co-edited with
Brion Gysin and Bernard Heidsieck. Chopin
performed some of his concrete poetry the
same year at the ICA and contributed to the
touring show Fluxshoe, organized by David
Mayor and Ken Friedman in 1972. He was
based at Ingatestone in Essex from the late
1960s until the death of his wife in 1986,
when he returned to France.

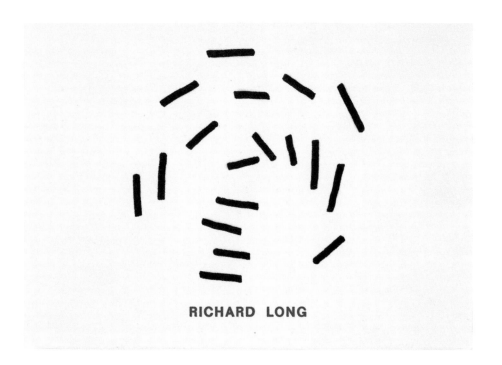

RICHARD LONG

RIVER AVON DRIFTWOOD

76 Richard Long, *Richard Long*, 1975
10.5 × 15.0 cm (4 ¼ × 6 in)
Postcard invitation to private view on 24 April
1975 at Galerie Yvon Lambert in Paris

77 Richard Long, *River Avon Driftwood*, 1976
10.5 × 15.0 cm (4 ¼ × 6 in)
Postcard invitation to exhibition from 15 May to
11 June 1976 at Konrad Fischer in Düsseldorf

Although Richard Long exhibited throughout
the 1970s at major art galleries in Europe,
he was regularly drawn back to his home town
of Bristol for the images he designed for his
invitation postcards, particularly to the Avon
Gorge. The double image for the Fischer
postcard echoes the single composition used
the previous year for the Galerie Yvon Lambert
show in Paris, and relates closely to Long's
Wide White Space invitation in Belgium also
in 1975, as well as his postcard invitation of
1976 for Gian Enzo Sperone's exhibition in
Rome. These postcard works are all illustrated
in Richard Long's book *Postcards 1968–1982*,
published in 1984 by the Musée d'Art
Contemporain, Bordeaux.

78 Simon Cutts, *No Free Reading*, 1996
10.5 × 15.0 cm (4 ¼ × 6 in)
Postcard published by Coracle at
workfortheeyetodo, 51 Hanbury Street, Brick
Lane, London

Simon Cutts appropriated this phrase from
the newsagent's window at Dublin bus station.
At the top of the message side of the postcard
the opening times of workfortheeyetodo
were given as Thursday to Sunday 11–6.
Previously situated further east, in Narrow
Street, the gallery workfortheeyetodo was also
the headquarters of Cutts's printing project,
Coracle, before it moved to a farm in Ireland
in 1998. Richard Long and Hamish Fulton are
among the artists for whom Cutts has mounted
exhibitions and printed postcard invitations.
This postcard was reproduced by Steven
Leiber as the frontispiece of his major work in
the field, *Extra Art* (2001). *No Free Reading*
was the beginning of what Simon Cutts calls
his 'ongoing manqué-theoretical postcard
project', which includes *The Postcard Is a
Public Work of Art* (1996), *The World Exists
To Be Put on a Postcard* (2013), *The World
Has Been Empty Since the Postcard* (2015)
and *The Postcard Is Always Innocent* (2017).
This serial project is one aspect of Cutts's
engagement with the tradition of Stéphane
Mallarmé's *Loisirs de la poste*.

**79 Erica Van Horn, *Italian Lesson
No. 17,* 1999**
15.0 × 10.5 cm (6 × 4 ¼ in)
Published by Coracle at Ballybeg, Tipperary,
Ireland

The American writer and artist Erica Van Horn
took her Masters in Fine Art and Printing at the
School of the Art Institute of Chicago, before
travelling to London in the 1980s, where she
became a partner in Coracle. She now works
with her co-director of the press, Simon Cutts,
near Tipperary, Ireland.

NO FREE READING

ITALIAN LESSON No. 17
Mezzo - Marito
(half - a - husband)

Eduard Bal
Ben
Henryk Bzdok
Jorge Caraballo
Michael Gibbs
Horst Hahn
Robert Jacks
J.H. Kocman
Gerald Minkoff
Maurizio Nannucci
Muriel Olesen
Gabor Toth

"STAMPPOSTCARDS"
is limited to
250
numbered copies
+
13
copies reserved to
the collaborators
marked from
A to M.

Also some loose cards were stamped.

2¡8

© Guy Schraenen éditeur
Kaasrui 11 - 2000 Antwerpen - Belgium
D/2059/1977/3

STAMP POST CARDS

Guy Schraenen
éditeur

GREEN

LIBERTY

LIBERTY

80 Guy Schraenen, *Stampostcards*, 1977
10.5 × 15.0 cm (4¼ × 6 in.)
From complete set of twelve postcards
published by Guy Schraenen in Antwerp,
numbered 218 in an edition of 250, plus
thirteen artists' copies

The contributing artists, each with a single
rubber-stamped postcard, were: Eduard Bal,
Henryk Bzdok, Jorge Caraballo, Michael Gibbs,
Horst Hahn, Robert Jacks, J. H. Kocman,
Gérald Minkoff, Maurizio Nannucci, Muriel
Olesen, Gabor Toth and Ben Vautier. In 1965
Guy Schraenen founded Galerie Kontakt in
Antwerp, where he dealt in contemporary
art until 1978. He also founded in 1973 his
publishing house Guy Schraenen Editeur,
operating for many years in Paris as well as in
Antwerp and producing distinguished artists'
books and postcard editions.

3. Postcard Invitations

The 1960s and 1970s in America and Europe were a golden age for the postcard invitation, often involving the artist in the design and frequently illustrating material unfamiliar from other sources. Among the leading gallery practitioners in this field in Europe were Wide White Space in Antwerp (fig. 89), Konrad Fischer (fig. 95), Alfred Schmela (fig. 86) and Gerry Schum (fig. 87), all in Düsseldorf, René Block in Berlin, and Kabinett in Bremerhaven; in Britain the Nigel Greenwood (fig. 88), Jack Wendler and Lisson (fig. 49) galleries; and in America the John Gibson (fig. 39), Paula Cooper (fig. 33), John Weber (fig. 102), and Leo Castelli (fig. 83) galleries, all in New York. A high proportion of their postcard invitations were to exhibitions by significant artists of the period.

John Gibson in New York and Nicholas Logsdail of the Lisson Gallery in London sometimes traded artists, with Richard Long and John Hilliard represented by intriguing invitations for both galleries. Wide White Space in Antwerp and Kabinett für aktuelle Kunst in Bremerhaven developed distinctively different styles of exhibition announcement, the former usually with black-and-white photographs on one side and the latter generally with a simple graphic presentation. Kabinett's invitations were most effective for shows by Stanley Brouwn, the elusive Dutch conceptualist, who, before his death in May 2017, requested that owners destroy any work of his they might have.

This period witnessed the beginning of site-specific exhibitions that were removed and destroyed after the show. Gallery invitations, frequently with printed shots of the individualized spaces, therefore became a lasting record of the work itself, free to anyone around at the time. Carl Andre (fig. 89) reflected on invitation postcards in an interview of 2002: 'I have always liked the postcard form. The date and place of a show takes up very little space so I have usually used the rest for an image or a text related to the show. I have never used an image of the work itself, or very seldom.'[34]

Eleanor Antin also takes care over postcard invitations to her shows, during the 1970s often posing for the illustrated images herself (fig. 137). Antin was the creator in California of a particularly important series of postcard works, including *100 Boots By the Bivouac* (fig. 27), about which she wrote years later: 'I see it as a kind of pictorial novel that was sent through the mail, came unannounced, unasked for. It came in the middle of people's lives.'[35]

Almost all invitation postcards bear the date, often with instructive textual and pictorial inferences, and personally addressed to artist friends, particular collectors or museum contacts.

Giuseppe Penone was the youngest of the avant-garde Italian artists grouped under the term Arte Povera. His creative power is evident in the postcard invitation (fig. 94) to his solo show in Milan in 1970, when he was only twenty-three, with its strong choice of black-and-white image on the front. For the invitation to his Lisson Gallery show of 1975, Richard Long reproduced one of his own photographs, which never became a physical work. It was described by Michael Compton in his essay on the artist's Venice Biennale exhibition of 1976 as 'a miniature multiple…not to be hung on the wall but to be received in the post and perhaps propped on the chimney piece'.[36] These invitation postcards are a valued resource, for both factual information and visual pleasure.

In the 1970s the photographs on postcard invitations to performances by, for instance, Dennis Oppenheim (fig. 45) or Joseph Beuys (fig. 85) are a delight in themselves, as well as being art historically informative. It is not simply the image that matters but the object itself, the type of paper, the method of printing, the postage stamp and frank, the addressee and the feeling of a previous period of artistic life and work. Even when the image may be known from a recent work of scholarship or a museum website, sight of the actual artist's postcard, in its original size, the details of the photograph fully realized, brings us closer to the experience of the era.

Sadly, over the past two decades posted postcard invitations have mostly been replaced by large, thick private-view cards, designed to impress with their brash double-sided printing, sent out in an envelope. This method is itself in the process of being superseded by non-physical email and Facebook invitations.

81 Andy Warhol, *Holy Cow! Silver Clouds!! Holy Cow!,* 1966
19.0 × 25.0 cm (7½ × 9 ⅞ in.)
Large postcard invitation to the Museum Members of the Contemporary Arts Center, Cincinnati, Ohio, to the opening of the Andy Warhol exhibition on 17 May 1966

This invitation image is formed of a black and silver-sheen grid of twelve self-portraits. It follows the identical pose of the grid of nine multicoloured silk-screen canvases, also of 1966, now in the Museum of Modern Art, New York, one of the earliest versions of a form of portraiture that became Andy Warhol's signature method. The back is designed for posting. In the same year Warhol also published an offset lithograph of this photographic self-portrait in an edition of 300 printed on silver paper.

**82 Bruce Nauman, *Holograms,
Videotapes and other works*, 1969**
18.5 × 23.5 cm (7 ⅜ × 9 ⅜ in.)
Large postcard announcement of an exhibition
in May 1969 at the Leo Castelli Gallery,
New York

The exhibition invitation illustrates a lesser-
known area of Bruce Nauman's work, his
self-focused holograms. This example was
posted to Ad Petersen (see fig. 133), the
Dutch artist and curator at the Stedelijk
Museum, Amsterdam.

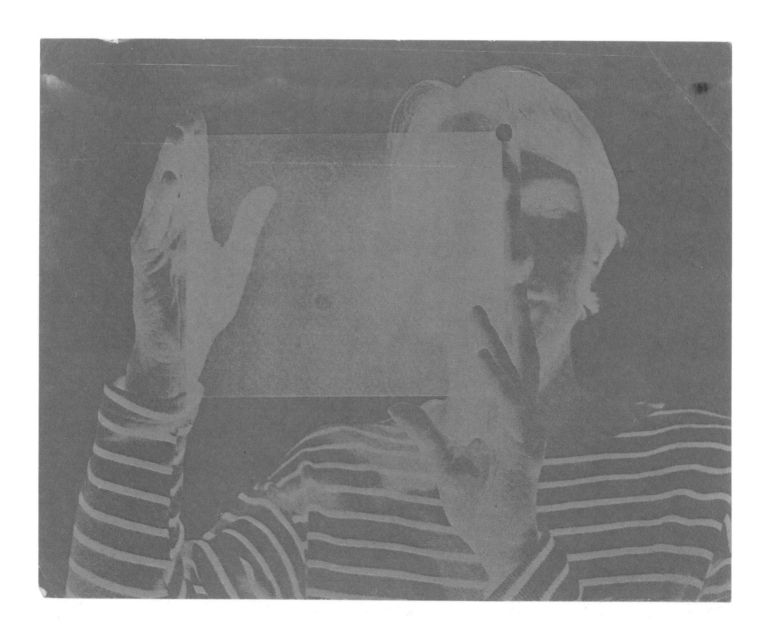

83 Robert Rauschenberg, *Cardboards and Cardbirds*, 1971
13.0 × 20.0 cm (5 ⅛ × 7 ⅞ in.)
Cardboard invitation to opening on 16 October 1971 of exhibitions at, respectively, Leo Castelli Gallery, 420 West Broadway, New York, and Castelli Graphics, 4 East 77, New York

The invitation for this double show, printed on cardboard, becomes a work of art in its own right, chosen by Robert Rauschenberg to reflect his wider use of the material in collaged paintings, as well as in the composite *Cardboards* series of 1971–72. The related term *Cardbirds* was given by the artist to his overlapping wall pieces in the shape of birds, made of found cardboard. Rauschenberg's use in his work of cardboard and other non-fine-art materials reflected his antagonism to hierarchies of all kinds.

CARDBOARDS LEO CASTELLI 420 W. B'WAY OCTOBER 16

CARDBIRDS CASTELLI GRAPHICS 4 EAST 77 OCTOBER 16

84 Joseph Beuys, *Bits and Pieces*, 1976
14.9 × 20.8 cm (5 ⅞ × 8 ¼ in.)
Postcard invitation to an exhibition of Caroline
Tisdall's Beuys Collection from 22 March to
10 April 1976 at the Generative Art Gallery,
125 Shaftesbury Avenue, London

The photograph is of Joseph Beuys standing
beside an early version of his glazed cabinets,
containers for his gathering of 'bits and pieces'.
Generative Art Gallery, Paul Neagu's fictional
alter ego, was run in his own studio by Beuys's

Romanian-born artist friend, who in the same
year received a solo show at the Museum
of Modern Art, Oxford, 'Paul Neagu and the
Generative Art Group'. This invitation was
posted from Stockwell, South London, on 30
March 1976 to Armin Hundertmark in Berlin.
Hundertmark was a leading publisher of Fluxus
material, including concrete poetry. In 1970 he
founded Edition Hundertmark at the age of only
twenty-two and went on to publish, between
1970 and 1975, forty different box editions,
one of them by Beuys.

85 Joseph Beuys, *I like America and America likes Me*, 1974

15.0 × 10.5 cm (6 × 4¼ in.)

Postcard invitation with X-ray portrait photo by Ute Klophaus for performance from 10 a.m. on 21 May to 6 p.m. on 25 May 1974 at René Block Gallery, New York

This performance by Joseph Beuys marked the opening of the René Block Gallery in New York. Beuys flew in to John F. Kennedy International Airport and, covered in a layer of felt, was carried by stretcher to an ambulance and driven straight to Block's gallery in West Broadway. Beuys shared a cage in the gallery for three days with a coyote, representing America's untamed spirit. The two swapped beds, the coyote settling down on Beuys's felt and Beuys sleeping in the coyote's straw. At the end of the performance Beuys was taken by the same method back to the airport in order to return to Germany, having seen nothing in America other than the inside of the Block gallery and the coyote.

86 Gordon Matta-Clark, *Conical Intersect*, 1975/1977
10.5 × 15.0 cm (4¼ × 6 in.)
Postcard invitation to opening on 12 February 1977 at Galerie Schmela, Düsseldorf

The image selected to illustrate this exhibition of video work was of Gordon Matta-Clark's intervention on the building at 27–29 Rue Beaubourg, Paris, due to be demolished to make way for the Pompidou Centre, one year into construction at the time. The photograph was taken by Marc Petitjean in October 1975. It reveals the skeleton of the Piano/Rogers museum behind work in progress on Matta-Clark's piece, on which he laboured personally for a hectic fortnight with his team, wielding power tools and traversing the vertiginous site.

87 Barry Flanagan, *A Hole in the Sea*, 1969
9.8 × 14.5 cm (3 ⅞ × 5¾ in.)
Postcard invitation to video screening on 28 March 1969 at Gerry Schum's Videogalerie, Düsseldorf, as part of the Land Art project

This invitation postcard was made with a circular die-cut hole in an image from Barry Flanagan's video. A different still from the video is illustrated by Lucy Lippard in her book *Six Years* (1973). The film was shot on the beach by the harbour in Scheveningen, Holland, because the artist maintained that 'the sea is the author of the work'.[37] The effect was achieved by the artist securing a Perspex cylinder in the sand, its sides unseen by the camera as the tide came in, appearing to disappear down a hole in the sea. Flanagan became known as a sculptor, but accepted this invitation from Schum to make a video, as did his recently graduated co-students at Saint Martin's School of Art, London, Gilbert & George.

88 Joel Fisher, *Photo of Matt E. Mulsion by Joel Fisher* and *Photo of Joel Fisher by Robin Klassnik*, 1979
10.3 × 14.7 cm (4 ⅛ × 5 ⅞ in.)
10.3 × 14.7 cm (4 ⅛ × 5 ⅞ in.)
Pair of postcard invitations to opening on
18 November 1979 for a Joel Fisher installation
at Matt's Gallery, Martello Street, London,
running from 19 to 25 November 1979

In a series of postcards made for solo
exhibitions in the 1970s and early 1980s,
Joel Fisher focused on images of the eyes of
curators, paired with their photos of his own
eye. In the case of this 1979 pair of postcards,
with identical information on the backs of
both, the eye photographed by Fisher is Robin
Klassnik's Old English sheepdog called Matt
E. Mulsion. Klassnik named his gallery, which
opened earlier in 1979 and still flourishes, after
his dog. The other contemporary art dealers
who gave Fisher exhibitions and participated in
eye postcards include Leo Castelli for a group
show in 1972 and Nigel Greenwood, with six
solo Fisher shows between 1972 and 1989.

89 Carl Andre, *Al/Cu*, 1969
10.5 × 15.5 cm (4¼ × 6 ⅛ in.)
Postcard announcement of exhibition from
20 September to 16 October 1969 at Wide
White Space, Antwerp

Carl Andre remembers having to paint the
floor of Konrad Fischer's gallery himself
before mounting the opening show there in
October 1967. Titled 'Ontologische Plastik',
the exhibited work was a steel floor piece,
which impressed Wide White Space so much
that they immediately arranged to exhibit Andre
in their last show at the old premises, in spring
1968, then again several times in the new
space at No. 2, Schilderstraat. The invitation
for *Al/Cu* was designed by Andre, the work
consisting of rolled-up strips of metal that
could be unfurled appropriately to fit the room.

90 Marcel Broodthaers, *Musée d'Art Moderne. Département des Aigles*, 1971

10.5 × 14.1 cm (4¼ × 5 ⅝ in.)
Postcard invitation to the cinema section of the gallery at Wide White Space, Düsseldorf, in 1971

This invitation postcard was sent in 1971 to the writer and collector Harry Ruhé in Amsterdam. It records Marcel Broodthaers invention and display from 1968 of his conceptual museum, questioning the established practice of acquisition and exhibition by international collections. The various sections shown by Broodthaers comprised reproductions of works of art, fine-art crates, wall inscriptions and film elements. Wide White Space was founded in Antwerp in 1966 by the Belgian art historian Anny de Decker and the German artist Bernd Lohaus. In 1973 they opened in Brussels a second gallery, closing both spaces in 1976, after exhibiting many of the major avant-garde European and American artists.

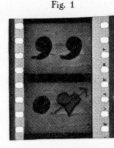

MUSEE D'ART MODERNE
DEPARTEMENT DES AIGLES

Fig. 1

- 1968 . Bruxelles XIXᵉ siècle
- 1969 . Antwerpen XVIIᵉ siècle
- 1970 . Düsseldorf XIXᵉ siècle (bis)
- 1971 . Düsseldorf section cinéma

L'ensemble d'objets figurant Burgplatz 12 à Düsseldorf au "Département des Aigles" (section cinéma) est en vente par l'intermédiaire de la Wide White Space Gallery. Catalogue spécial sur demande (prix 600 fr.). Tél. 03 / 38 13 55.

Die Gegenstände, die sich im "Département des Aigles" (Section Cinéma) Düsseldorf, Burgplatz 12 befinden, werden durch die Wide White Space Gallery verkauft. Besonderer Katalog auf Anfrage (Preis 600 Bfrs.). Tel. 03 / 38 13 55.

91 Marcel Broodthaers, *The Manuscript found in a bottle*, 1974

10.5 × 15.0 cm (4¼ × 6 in.)
Postcard invitation to exhibition from 12 October to 2 November 1974 at Galerie René Block, Berlin

René Block had opened his Berlin gallery in 1964 and became one of the main presenters in Germany of Neo-Dada. He opened a branch of the gallery in New York in 1974; it remained in business until 1977. In the late 1970s Block became programme director of the Deutscher Akademischer Austauschdienst (DAAD), in which capacity he organized stipends for the Fluxus artists Geoff Hendricks, Dick Higgins, Alison Knowles, Robert Watts and Emmett Williams. After George Maciunas's death in 1978, Fluxus activity centred itself in Germany.

Das Manuskript in der Flasche ist der Titel unserer neuen Edition von 120 Flaschen, die wir zusammen mit anderen Flaschenobjekten vorstellen. Die Eröffnung der Ausstellung ist am Freitag, dem 11. Oktober um 21 Uhr.

1833
————
1974

Vom 12. Oktober bis
zum 2. November 1974
Mo–Fr 14–18,
Sa 10–13 Uhr

Marcel Broodthaers

Galerie René Block Berlin 15 Schaperstraße 11 Telefon 211 31 45

92 Sol LeWitt, *Grids & Color*, 1981
15.0 × 10.5 cm (6 × 4¼ in.)
Postcard invitation to opening on 13 February
1981 at the Frankfurter Kunstverein, Frankfurt

The exhibition was of Sol LeWitt's 'Fifty Silk
Screen Prints Using all Combinations of Grids
and Color', the illustration on the front of his
piece *Frankfurt am Main*, an unusual postcard
image for LeWitt. From the 1960s onwards
LeWitt contributed significantly to the
development of the artist's book, including
a show curated by Joseph Kosuth, in 1969
at the Lannis Gallery, New York, to which
he, Carl Andre, Robert Ryman, Mel Bochner,
Robert Smithson and other artists sent in their
favourite book.

Giuseppe Penone Galleria Toselli Borgonuovo 9 Milano giovedì 23 aprile

93 Michelangelo Pistoletto, *Pistoletto*, 1964
13.5 × 18.5 cm (5 ⅜ × 7 ⅜ in.)
Invitation to opening on 4 March 1964
at the Galerie Ileana Sonnabend, Paris

Michelangelo Pistoletto was still only thirty
years old when his first solo exhibition was held
at the prestigious Galerie Ileana Sonnabend
in Paris. He illustrated his mirror painting
Tavolino con bicchieri in black and white on
the private-view invitation. The year before, in
April 1963 at the Galatea show in Turin, Ileana
Sonnabend had bought all of Pistoletto's newly
invented mirror paintings, many of which were
re-exhibited in Paris. After different experiments
with his mirror ideas, the artist had by 1963
perfected the technique, with a sheet of mirror-
finished stainless steel fitted with an image
obtained by tracing a photograph, enlarged to
life size, with the tip of a brush, on tissue paper.

94 Giuseppe Penone, *Giuseppe Penone*, 1970
23.0 × 17.0 cm (9 ⅛ × 6¾ in.)
Invitation card to opening on 23 April 1970 at
Galleria Franco Toselli, Milan

Giuseppe Penone was only twenty-three
at the time of this exhibition in Milan. He
was youngest of the Italian artists grouped
under the term Arte Povera, which included
Michelangelo Pistoletto, Alighiero Boetti and
Giovanni Anselmo. Penone contributed in 1977
to a group show at Gian Enzo Sperone's in
Rome, the postcard invitation a grid of twelve
portrait photos of the artists, including Joseph
Kosuth, Mario Merz, Penone, Joseph Beuys
and Anselmo.

15.0 × 9.0 cm (6 × 3 ⅝ in.)
Postcard invitation to an exhibition private view
on 3 September 1969 at the Konrad Fischer
Galerie in Düsseldorf, for a joint exhibition with
Richard Sladden

This was Bruce Mclean's first show, which he
decided to share with the sculptor Richard
Sladden. It took place in Konrad Fischer's first
Düsseldorf gallery. McLean studied at Saint
Martin's School of Art, London. His fellow
students included Barry Flanagan, John
Hilliard and George of Gilbert & George.
McLean worked on an interview sculpture
with Gilbert & George at the Hanover Grand
in 1969. In 1971 he formed the 'the world's
first pose band' called Nice Style with four art
students from Maidstone College of Art. Two
years later McLean made a series of black-
and-white photographic postcards, one for
Nice Style and its *GRAB IT WHILE YOU CAN*
performance in Oslo. The group disbanded in
1974 after its highly successful work, *High up
on a Baroque Palazzo*.

96 Richard Long, *Sculpture*, 1968
9.0 × 14.0 cm (3 ⅝ × 5 ⅝ in.)
Postcard invitation to exhibition at Konrad
Fischer Galerie, Düsseldorf, 21 September
to 10 October 1968 (front and back)

In the second year of exhibitions in Düsseldorf
Konrad Fischer gave Richard Long his
first public solo show. For the invitation to
the exhibition the gallery adapted a stash
of commercial postcards published by
Plastichrome in 1965, of Clifton Suspension
Bridge, Bristol, silk-screening the artist's name
across the front. Long, whose parents lived
close to the bridge, has made the river and
gorge an important part of his artistic life, using
River Avon mud in hand-painting on gallery
walls on regular occasions. The cyclist in this
invitation postcard has been misdescribed as
Long himself. For his next show at the Konrad
Fischer Galerie, in May 1970, a commercial
postcard of St Kilda was appropriated for the
invitation. The hiker in that postcard was also
mistaken for the artist.

4. Political Postcards

Postcards have long been put to polemical use. In his novel *Alone in Berlin*, published in German in 1947, Hans Fallada invented a character who secretly deposited in public places around wartime Berlin postcards with critical comments on fascism. The perpetrator says to his wife: 'Even if the only effect is to remind them that there still is resistance out there, that not everyone thinks like the Führer…We will inspire other people to write their own postcards…We will inundate Berlin with postcards, we will slow the machines, we will depose the Führer, end the war….'[38]

In the 1970s the artist Genesis P-Orridge made radical use of postcards (fig. 126). Accused in 1975 of obscenity for his mailed postcards of the Queen, P-Orridge was supported by the American author William Burroughs, who addressed a letter to the court stating: 'The postal cards in question were certainly intended neither to titillate nor to offend, but to instruct by pointing up banality through startling juxtapositions.'[39] John Kasmin, Tim Head, Robin Klassnik, Brion Gysin, Anna Banana and Nigel Greenwood were among the art-people invited by P-Orridge to attend his trial.

In America the Fluxist Alison Knowles and composer Pauline Oliveros designed and published in the mid-1970s a series of five postcards, whose titles speak for themselves: *Beethoven was a lesbian* (fig. 112); *Chopin had dishpan hands*; *Bach was a mother*; *Brahms was a two-penny harlot*; and *Mozart was a black Irish washerwoman*. Oliveros is executive director of the organization that she formally founded in 1985 as the Deep Listening Institute, her musical practice based on principles of improvisation, electronics, ritual and meditation. During the same period in Germany, Renate Bertlmann expressed similar feminist views in her postcard set *AMO, ERGO SUM* (fig. 114), later the title of a monograph on the artist. In 2017, the postcards were included in her solo show at Fotohof, Salzburg.

The best political and polemical postcards spring from convictions deeply held by their creators. In the late 1970s and early 1980s a series of outstanding posters and postcards by Peter Kennard used in imaginative form the technique of photomontage, until then largely neglected in Britain. The cards were commissioned by the Campaign for Nuclear Disarmament, of which he was a committed supporter, the majority published for CND by the socialist cooperative Leeds Postcards (fig. 103).

Prime Minister Margaret Thatcher inspired hundreds of polemical postcards. Two examples spring to mind: *Crime Wave* (fig. 109), designed by Steve Hardstaff for his Liverpool imprint South Atlantic Souvenirs; and Paul Morton's *Thatcher Therapy. Dot-to-Dot Puzzle No. 1* (fig. 107), published by Leeds Postcards. Mark Pawson is one of a number of other artists working to produce and distribute subversive postcards, including his *Reduce Reuse Repair Recycle* series, hand-printed in different colourways on his kitchen table.

In New York Alfred Gescheidt began working with photomontage in the 1960s, creating many examples for publication by the American Postcard Company. Like Kennard, Gescheidt mostly used photomontage and favoured particular political themes, in his case the practice of Safe Sex, of special concern at the time in 1980s AIDS-ravaged New York. The postcard from an adjusted photograph of President Reagan with an enlarged condom on his head is typical of Gescheidt's humour, captioned, with conscious misspelling: 'Condoms? Yeah, I alwais use them in the shower…' (fig. 101). Like Thatcher, Reagan was much ridiculed in postcards, powerfully by the campaigning artist Hans Haacke in *The Lord's Prayer* (fig. 100), self-published in 1984. In his lecture 'Show and Tell' at Lake Como in July 2010, Haacke said: 'I've always been interested in opening art spaces to the outside world, not only in the physical sense. I believe the art world is not a world apart. In spite of what many claim, there are no boundaries.'[40] Haacke's antagonism to the moneyed exclusivity of the art scene extends to his refusal, ever since visiting Cologne Art Fair in the late 1960s, to allow dealers to exhibit work by him at an art fair, which these days is the dominant commercial forum for buying and selling contemporary art.

Criticism of the money structures in the art world was expressed by dissident artists in public work of various kinds, such as performance protest and in publication of alternative magazines and pamphlets, as well as in the distribution of posters and postcards.

97 Jasper Johns, *Art for the Moratorium*, 1969
15.2 × 20.4 cm (6 × 8 ⅛ in.)
Jumbo Post Card invitation to attend the exhibition and fundraising sale of work by Jasper Johns and others from 11 to 13 December 1969 at Leo Castelli Gallery, New York

This image by Jasper Johns was made by Leo Castelli into a poster edition limited to 300, for sale at $100 each in aid of the Vietnam Moratorium Committee. Johns's anti-Vietnam green, black and orange flag in the postcard derives from his painting, which is now in the Museum of Modern Art, New York. That picture depicts a double flag with a grey-painted flag at the bottom and an orange, black and green flag at the top. This invitation was open-mailed to Nigel Greenwood, the leading young London dealer in contemporary art, who held early shows by Gilbert & George. In a 2015 interview with Greenwood's daughter, published in 2016, they said: 'The artists needed Nigel because existing galleries wouldn't show art by people like us.'[41]

© Jasper Johns, 1969

MORATORIUM

WAR
IS
OVER!

IF YOU WANT IT

Happy Christmas from John & Yoko

Later versions of this card, which was designed
in 1969, replaced the phrase 'Happy Christmas
from John & Yoko' with 'Love and Peace from
John & Yoko'. In the summer of 1970 George
Maciunas mounted 'Fluxfest Presents John &
Yoko' at a variety of New York venues, including
Joe Jones's Tone Deaf music store. Both artists
were regularly involved in Fluxus events, as
reflected in their use of postcards in this form.

99 Jenny Holzer, *The Beginning of the War Will Be Secret*, 2002
9.0 × 14.0 cm (3 ⅝ × 5 ⅝ in.)
Front and back of balsa-wood postcard
published by Printed Matter, Inc. in New York
for their 2002 show 'Protect Me From What
I Want' of Jenny Holzer multiples and editions

Jenny Holzer began making use of words in
her work in the late 1970s, employing a wide
variety of means to disseminate her political
comments, including postcards, printed leaflets
and T-shirts, neon signs, banners, carved
stone and digital LED boards. These wooden
postcards are part of what Iwona Blazwick
described in the 1988 catalogue of Holzer's
solo show at the Institute of Contemporary Arts,
London, as 'aiming her message at a general
public by stepping outside the gallery and into
mass culture'.[42] Set up in New York in 1976 by
Sol LeWitt, Lucy Lippard and others, Printed
Matter, Inc. is a not-for-profit organization still
highly active today, stocking an exceptional
variety of artists' books and ephemera from
around the world.

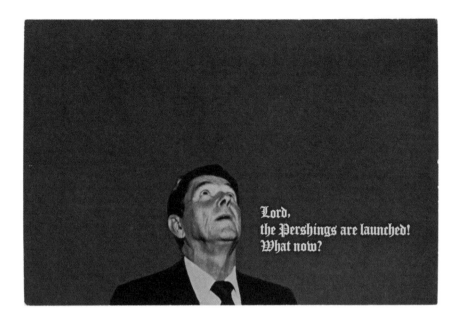

100 Hans Haacke, *The Lord's Prayer*, 1984
10.5 × 15.0 cm (4¼ × 6 in.)
Postcard published by the artist with a
photograph of Ronald Reagan looking to the
sky, captioned in white Gothic lettering, 'Lord,
the Pershings are launched! What now?'

Hans Haacke produced for a New York show in
1982 an invitation in the form of an anti-Reagan
postcard titled *Cuts*. The following year, for a
solo exhibition at the John Weber Gallery, he
made a similarly themed invitation postcard,
Star Wars, adapting an image from a Ronald
Reagan whisky advert. Haacke has long been
suspicious of the workings of the art world, as
expressed in *Free Exchange* (1995), a dialogue
with Pierre Bourdieu: 'Public funds are always
at risk of being used to support mediocrity or
to keep an art bureaucrat on the payroll.'[43]

**101 Alfred Gescheidt, *Safe Sex*, 1982,
republished *c.* 2005**
15.0 × 10.0 cm (6 × 4 in.)
Alfred Gescheidt image first published as
No. 352 with his regular postcard makers,
the American Postcard Company

A pioneer of photomontage, Alfred Gescheidt
published his book *The Illustrated Surgeon
General's Report on Cigarette Smoking* in
1992. Along with smoking, cats were another
favourite Gescheidt topic. The reverse of this
example of his *Safe Sex* postcard bears an
Apple insignia, indicating republication by
the computer giant at a later date than the
American Postcard Company original edition
of 1982.

102 Hans Haacke, *Upstairs at Mobil*, 1981
15.2 × 10.0 cm (6 × 4 in.)
Postcard invitation to exhibition from 7 February
to 4 March 1981 at John Weber Gallery,
New York

Hans Haacke was born in Cologne, Germany,
and in his formative years was part of the
Zero association of artists. In 1967 he moved
permanently to New York, where his work
leant towards political controversy. The title
of this 1981 show refers to the popular British
television series *Upstairs, Downstairs*, which
Mobil sponsored on the American Public
Broadcasting Service. Haacke produced
ten large panels quoting from the chairman's
statements, acquired by the artist by being
a shareholder. Interviewed for *Parachute*
magazine in 1981, Haacke said of his Mobil
campaign: 'There are some comforting
indications that my stuff did not go unnoticed…
My work is not done with a clenched fist, nor
I hope, is it so dry that it isn't fun to look at.'[44]

103 Peter Kennard, *Haywain*
Constable (1821) Cruise Missiles,
USA (1983), **1983**
10.5 × 15.0 cm (4¼ × 6 in.)
Photomontage postcard published by Leeds
Postcards on behalf of the Campaign for
Nuclear Disarmament

Peter Kennard made this image to criticize
government promotion of the US Cruise Missile
bases at Greenham Common and Molesworth
and to protect the countryside. A black-and-
white version had been published as a CND
poster in 1980, after first appearing in July 1980
in *Camerawork*, illustrating E. P. Thompson's
article 'The State of the Nation'. The colour
postcard was published in 1983 and the original
faded collage for the piece was purchased by the
Tate in 2007. The writer John Berger described
Kennard's work as 'pure and dirty'. Kennard's
Domesday Book. A photo poem was published
by Manchester University Press in 1999, with a
foreword by the playwright Harold Pinter.

104 kennardphillipps, *Photo Op*, 2005
15.0 × 10.5 cm (6 × 4¼ in.)
Postcard published by Gestalten Space, Berlin,
from the book cover of Art & Agenda illustrating
the kennardphillipps photomontage *Photo Op*

According to the art critic Jonathan Jones,
writing in *The Guardian* in October 2013, the
kennardphillipps photomontage *Photo Op* 'has
become the definitive work of art about the war
that started with the invasion of Iraq in 2003.
Ten years on from the war's beginning, this
manic digital collage states succinctly what a
large number of people feel and believe about
Blair's responsibility for the chaos that ensued.
It says in a nutshell what protesters claimed
at the time and what has since become a
generally accepted version of history, that Tony
Blair was a monster charging into Iraq without
scruples. Look, there he is, taking a selfie in
front of his handiwork. Such is his notoriety
that viewers really can take this as fact.'

**105 Jonathan Horowitz, *Does she have a
good body? No. Does she have a fat ass?
Absolutely*, 2017**
15.2 × 10.1 cm (6 × 4 in.)
Anti-Trump postcard published by Primary
Information, a Brooklyn-based not-for-profit
organization

The multidisciplinary artist Jonathan Horowitz's
postcard is part of an ongoing series critical
of the Trump Administration published by
Primary Information, commissioned as original
postcards from various artists. Founded in
New York in 2006, Primary Information states:
'Postcards have long been a part of the artist
book tradition, with artists engaging with the
form for well over fifty years now. Primary
Information...sees the need to double down on
this form as a political space embedded with
the urgency, diversity, and complexity of voices
that are the hallmark of our times. Who better
to do this than artists?'[45]

I DON'T GIVE A SHIT WHAT YOUR HOUSE IS WORTH

106 Leeds Postcards, *I don't give a shit*
what your house is worth, **1988**
15.0 × 10.5 cm (6 × 4¼ in.)
Instant Response Unit No. 4 published by
Leeds Postcards

Leeds Postcards, which was founded in 1979,
was inspired by the political postcard work of
Klaus Staeck in Germany, similarly dedicated to
radical activism. The British postcard publisher
worked with most of the unions and other
campaigning organizations of the period. The
stamp insignia on the back of their cards, of a
boxing glove on a spring, was designed by Pete
Smith. Leeds Postcards became a cooperative
in 1986, until debt forced it to cease trading in
1996. A member of the cooperative, Christine
Hankinson, took over the stock in 1996
and continued the imprint from her home
in Headingley, Leeds.

107 Paul Morton, *Thatcher Therapy.*
Dot-to-Dot Puzzle No. 1, **1984**
15.0 × 10.5 cm (6 × 4¼ in.)
Postcard published by Leeds Postcards

The caption reads on the reverse: 'Thatcher
Therapy. Take a broad, black, water-based
felt-tip pen and follow the dots until Mrs
Thatcher's face is obliterated. Wipe clean and
it's ready for the next go. In no time at all you'll
be looking forward to starting the day with fresh
vigour.' The illustrator Paul Morton set up Hot
Frog Graphics in Yorkshire in the mid-1980s.
Leeds Postcards published in 1989 a book
of his work, *Drawing Conclusions: Political*
Postcards, in which he described Margaret
Thatcher's live TV appearance in May 1983
to discuss the *Belgrano* affair as one of the
few public occasions when she looked visibly
worried about her actions.

108 David Evans, *England's Glory*, 1987
10.0 × 15.0 cm (4 × 6 in.)
No. 4 of the Belgrano File, a set of four
postcards published in 1983, 1984, 1986
and 1987 by Leeds Postcards

David Evans quotes on the reverse of
his postcard from Elvis Costello's song
'Shipbuilding' (1983): 'It's just a rumour that
was spread around town / A telegram or a
picture postcard / Within weeks they'll be re-
opening the shipyards / And notifying the next
of kin.' Followed by information on the sinking
of the Argentinian ship *General Belgrano*:
'The Thatcher government has succeeded so
far in hiding many facts, including that of the
cover-up itself, in a cloak of Official Secrecy.
The truth is enough eventually to sink her.'
Evans was the winner of the 'Shipbuilding'
competition launched by Leeds Postcards
in November 1986.

Sunday 2nd May 1982 The *General Belgrano*

109 South Atlantic Souvenirs,
***Crime Wave*, 1982**
10.5 × 15.0 cm (4¼ × 6 in.)
Postcard SAS10 designed and published
in Liverpool

South Atlantic Souvenirs (SAS) was set up in
1982 by Steve Hardstaff and Rick Walker to
criticize the Falklands War, as implied in the
imprint's title. Between 1982 and the closure
of SAS in 1995, they published over 140
different postcards, mostly in editions of 2,000,
although for *Crime Wave* this rose to 30,000,
captioned on the reverse, 'What kind of people
are we?' Prior to working at SAS, Walker ran a
commercial print shop and Hardstaff designed
artwork for local rock bands, including the
Beatles with his work for Peter Blake and Jann
Haworth on the *Sgt Pepper*'s cover, before
designing records for Led Zeppelin, Fleetwood
Mac, Dead or Alive and many others.

**110 Leeds Postcards, *For goodness
sake*, 1993**
15.0 × 10.5 cm (6 × 4¼ in.)
Designed by Copley, Daly, Wayne and published
by Leeds Postcards for the multi-agency Leeds
Racial Harassment Project

The reverse caption includes the information:
'Racial harassment is not a new phenomenon
in Britain. It is estimated that 70,000 racist
attacks occur every year with as few as 1 in
20 being reported.' Copley, Daly, Wayne, the
marketing company that designed and printed
this postcard, was founded in Batley, Yorkshire,
in 1985 and closed in 1996.

**111 Greenham Common, *Stop,
Standstill*, 1982**
15.0 × 10.5 cm (6 × 4¼ in.)
Postcard of demonstration by Oxford
Committee of 100 between 23 and 24
June 1982 at Greenham Common, at which
323 demonstrators were arrested and their
fingerprints taken by force, published by
W.F.L.O.E. Dyfed

Although the RAF Greenham Common
airbase, near Newbury, Berkshire, was run by
the British and Americans from 1942, it did
not become the focus of public protest until
the announcement in June 1980 that cruise
missiles were going to be based there. The
Peace Camp, which was started by men and
women, became all-female in February 1982,
initiated by a group of Welsh protesters,
their activities publicly recorded in a series of
postcards published by W.F.L.O.E. Dyfed.

112 Pauline Oliveros, *Beethoven was a lesbian*, c. 1973
10.5 × 17.5 cm (4¼ × 7 in.)
Postcard designed by Pauline Oliveros, photographed in her garden, printed by Alison Knowles Graphics, from a series of five

113 Pauline Oliveros and Alison Knowles, *Brahms was a two-penny harlot*, c. 1976
10.5 × 14.2 cm (4¼ × 5 ⅝ in.)
Images of Alison Knowles as a child on the beach and of the young Pauline Oliveros with a dagger, captioned, 'POSTCARD THEATRE alison knowles / pauline oliveros AENJAI GRAPHICS', from a series of five

In a booklet published in 2013 by AcquAvivA of Berlin on this 1970s self-published series of five postcards, the 'composeress' Pauline Oliveros described them as 'a comment on the outsider status of women in the music world – branding Beethoven as a lesbian was a way of turning the tables on the musical establishment'.[46] Oliveros helped with the publication by Left Hand Books of Dick Higgins's *Buster Keaton Enters Into Paradise* (1994). Higgins and Knowles were first married from 1960 to 1970, the main years of their Fluxus activities, and again from 1984 until Higgins's death in 1998. Their twin daughters Hannah and Jessie appear in two of this set designed solely as postcards.

114 Renate Bertlmann, *AMO, ERGO SUM*, 1980

15.0 × 10.5 cm (6 × 4¼ in.)
Two from a complete set of eight self-published postcards each signed by the artist

These postcards were made by Renate Bertlmann between 1978 and 1980 in a small number. She sent them out to friends and colleagues over this two-year period. Each postcard has its individual title on the reverse, designed in similar graphic style. Postcard number two, a self-portrait wearing dildos as earphones, inscribed on the front 'Chanson d'Amour', is titled on the reverse *Martha Wilson (N.Y.) gewidemet*. The dedication to the Fluxus artist Martha Wilson resulted from Wilson's earlier invitation to Bertlmann to exhibit at the Franklin Furnace in New York, the avant-garde arts centre she co-founded in 1976.

THE ADVANTAGES OF BEING A WOMAN ARTIST:

Working without the pressure of success.

Not having to be in shows with men.

Having an escape from the art world in your 4 free-lance jobs.

Knowing your career might pick up after you're eighty.

Being reassured that whatever kind of art you make
　　it will be labeled feminine.

Not being stuck in a tenured teaching position.

Seeing your ideas live on in the work of others.

Having the opportunity to choose between career and motherhood.

Not having to choke on those big cigars or paint in Italian suits.

Having more time to work after your mate dumps you
　　for someone younger.

Being included in revised versions of art history.

Not having to undergo the embarrassment of being called a genius.

Getting your picture in the art magazines wearing a gorilla suit.

Guerrilla Girls CONSCIENCE OF THE ART WORLD

I AM A lezzie butch pervert feminist amazon bulldagger dyke

AND SO ARE YOU

115 Guerrilla Girls, *The Advantages of Being a Woman Artist*, 1988/1990
14.4 × 10.5 cm (5 ¾ × 4 ¼ in.)
This text was first seen in the UK in Feminist Art News (FAN), Leeds, here published by Leeds Postcards

Guerrilla Girls was founded in New York in the mid-1980s by an anonymous collective of women artists. This postcard is one of the earliest public statements from the group, which is still active today. Its gorilla-masked film of 2016 documents the poster and leaflet campaign the Guerrilla Girls mounted criticizing rich collectors who bought art at outrageous prices on the back of low wages paid to their exploited workers. One of their best-known pieces was *Do Women Have To Be Naked To Get Into the Met. Museum*, which appeared on billboards in 1989.

116 Zoe Leonard, Joy Episalla and others, *And so are you*, 2008
15.2 × 10.1 cm (6 × 4 in.)
Postcard designed and published by fierce pussy

The collective fierce pussy, which was formed in New York in 1991, describe themselves on their website as 'a collective of queer women artists…[immersed] in AIDS activism'. Four of the original artists – Zoe Leonard, Nancy Brooks Brody, Joy Episalla and Carrie Yamaoka – still work together on occasion, exhibiting at Printed Matter, Inc. in 2008, when they published a book and this postcard.

117 Jill Posener, *Join Lesbians United*, 1981
10.5 × 15.0 cm (4¼ × 6 in.)
Postcard from photograph taken by the artist
of billboard intervention, published by the
Women's Press

**118 Jill Posener, *Renew his interest
in carpentry...*, 1981**
10.5 × 15.0 cm (4¼ × 6 in.)
Postcard from photograph taken by the artist
of billboard intervention in Finsbury Park,
London, published by the Women's Press

119 Jill Posener, *Free of little pricks,* **1982**
10.5 × 15.0 cm (4¼ × 6 in.)
Postcard from photograph taken by the artist
of billboard intervention, published by the
Women's Press

120 Jill Posener, *Born kicking,* **1983**
10.5 × 15.0 cm (4¼ × 6 in.)
Postcard from photograph taken by the artist
of billboard intervention, published by Acme
Cards of Leeds

Jill Posener was the first female member of
the theatre group Gay Sweatshop, set up
in London in 1975. In 1982 Posener's book
on graffiti *Spray It Loud* was published by
Routledge, with *Renew his interest in carpentry*
on the front cover. She writes in the introduction:
'I roam the streets with my camera in search
of the ultimate graffiti. I think I've seen the best
and more. I make no apologies for the harsher
comments.'[47] She subsequently moved to San
Francisco, where she founded the photographic
publishing company Picture This.

121 Leon Kuhn, *Statue of Liberty*, c. 2000
15.0 × 10.5 cm (6 × 4 ¼ in.)
Lenticular postcard published by Leon Kuhn
Cards with visual insignia on the reverse

By a small movement of this lenticular postcard,
the Statue of Liberty is seen to wear a Ku Klux
Klan hood. Leon Kuhn, a lifelong member of the
Socialist Workers Party, was born in London
in 1954 and died there in 2013, committing
suicide beneath a tube train at Finchley Road
Station. After returning from an extended stay
in Japan in his twenties, Kuhn occasionally
drew political cartoons for the *New Statesman*
and *Socialist Worker*, but the fact that most of
his work remained unpublished finally led him,
with the help of his brother, to promote his self-
published political postcards and posters in the
streets of London.

122 Cath Tate, *Prevent Street Crime*, 1982
15.0 × 10.5 cm (6 × 4 ¼ in.)
Photomontage by Cath Tate, published by
Leeds Postcards

This image has been published on 35,000
posters and over 100,000 postcards. Cath
Tate, who was taught photomontage by Peter
Kennard, initially made her name with work
published by Leeds Postcards, a reputation
confirmed by the appearance in 1987 of
her collection of cartoons *Kissing Toads*.
She continues to publish her own postcards
and greetings cards from Brixton, London.
The firm Cath Tate Cards is now co-managed
by her daughter.

30TH AVE A 14TH ST, QUEENS

TOMPKINS AVE AT HILL ST, STATEN ISLAND

**123 Gran Fury, *Women Don't Get AIDS
They Just Die From It*, 1991**

12.6 × 23.5 cm (5 × 9 ⅜ in.)
Postcard of two posters in Spanish and English
placed in bus shelters as part of Public Service
Art, presented by the Public Art Fund

The Museum of Contemporary Art, Los Angeles,
placed another eighty of these posters in bus
shelters throughout the city. Gran Fury was a
New York collective of eleven artists. Founded
in 1988 largely to deal with the AIDS crisis, it
was disbanded in 1996 after the death of key
member Mark Simpson. The collective was
known for its campaigning slogan 'We are not
making art, we are making war'.

5. Altered Postcards

There are artists who gather existing postcards and alter them into unique forms of highly personal expression. Some draw or paint onto old postcards, while others scratch and deface the surface. Artists transform postcards in different ways, with embroidery in wool or silk; the removal of parts of the image with erasers; the application of collaged paper; and cutting and pasting and rearranging postcards, sometimes on a relatively large scale. Given the inexpensive availability of the postcard, artists feel free to pursue all sorts of technical experiments.

Ray Johnson was one of the most respected – and prolific – manipulators of found material, including postcards (fig. 124). Johnson cut up and pasted and wrote over and tore holes in whatever printed material he happened upon, added postage stamps and shoved it into a letter box. His favourite drawn emblem was a rabbit's head, which appeared on typed letters sent to Robin Klassnik in the early 1970s, several years before Klassnik founded Matt's Gallery (fig. 88). In a conversation published in *Mail Etc., Art* (1980), Johnson said that the rabbit head 'derives from Mickey Mouse or Mickey Rat, or it's a mouse, or at times an elephant with a long proboscis. It's always expressive of who I feel I am at the moment I make that drawing'.[48]

In a unique work dated 1 June 1973, Genesis P-Orridge cut up a postcard he had printed himself earlier in the year and stuck the pieces in a different configuration on to another copy of the same card (fig. 126). Nicknamed Genesis at school, Manchester-born Neil Andrew Megson adopted the surname P-Orridge after living on a diet of porridge while at art school in Hull. He liked names, calling his art cooperative COUM Transmissions, short for Cosmic Organicism of the Universal Molecular: 'COUM was just a word, like Dada,' P-Orridge explained. Hull-born Christine Newby, a partner in his rock-band Throbbing Gristle, adopted the name Cosey Fanni Tutti in 1973, when Klassnik invented this perfect pseudonym for her.

Cristina Garrido initially used Tate postcards in painting out with acrylic the works of art illustrated, replacing them with the previously concealed background (fig. 130). Her sources and methods have widened, a recent development being to find postcards of the work of Gordon Matta-Clark and paint back *in* the cuts and removals in his buildings. Garrido's postcard in

the book hides a mattress by Rachel Whiteread. Whiteread's own altered postcards include punched holes in an alpine scene (fig. 129); similar works were exhibited in her retrospective at Tate Britain, London, from 2017 to 2018. Postcards take a central place in Whiteread's life and work; she keeps in her studio the Landseer postcard that she bought as an eight-year-old from the Tate Gallery and pinned to her bedroom wall.

Another British sculptor, Ruth Claxton, also makes postcard pieces from museum images by cutting away shapes in the surface, notably in a double portrait of Queen Elizabeth I, mounted in a colour-matched pheasant feather frame by Helen Knight (fig. 174). While the Swiss artist Nicolas Feldmeyer makes intricate overlapping collages of found postcards, usually in black and white.

Angus Fairhurst shared an exhibition at Tate Britain in 2004 with his friends Sarah Lucas and Damien Hirst. Unlike them, Fairhurst regularly worked with postcards – the early gridded example in this book was made in 1989 (fig. 127). He also worked on a batch of found postcards of Le Havre in a piece called *Wish you were here (I'm down to my last cigarette)* (1992), consisting of eight black-and-white topographical postcards, each with three cigarettes in front of them – for the last card one of the cigarettes is almost burnt out and another fallen over on to the ground. Both Lucas and Hirst have made several works with cigarettes.

Some artists make dimensional alterations to postcards. In 2015 David Horvitz, executed in Los Angeles an entrancing group of work by taping actual teaspoons he had pocketed over the years from cafés around the world on to the postcards he had made from photographs of these stolen spoons. He risked sending them unprotected through the normal post. For *Tautological Card No. 1* (2011) the leading Italian protagonist of mail art, Vittore Baroni, bought two identical tourist postcards of the yacht basin in his home town of Viareggio, folded one into a Lichtenstein-like sculptural boat and glued it into the harbour of the second postcard. Horvitz and Baroni are incessant makers of postcards.

124 Ray Johnson and Jerry Rothenberg,
***Cage One. Wires* (1), 1968**
8.0 × 14.0 cm (3¼ × 5⅝ in.)
Postcard designed and privately published
by Jerry Rothenberg, posted to Ray Johnson,
altered by him with rabbit face and stamp RAY
JOHNSONG and mailed back (front and back)

Until moving from New York City in 1972
and subsequently settling in San Diego, the
poet Jerry (Jerome) Rothenberg was closely
involved with Ray Johnson and other Fluxus
artists. Johnson studied art in the 1950s at the
radical Black Mountain College, North Carolina,
where he learnt collage. The most prolific and
inventive mail-artist of his time, Johnson gave
away most of the art he made, usually via the
US postal system, partly in protest against
the commercialism of leading galleries and
museums. In the 1960s, he coined the term
the New York Correspondence Society to
describe his postal art, changing it in 1973
to the Buddha University. Ardently anti-
commercial, Johnson mainly exchanged his
work, though on occasion he sold it to foreign
collectors from a New York motel room rented
by the half hour.

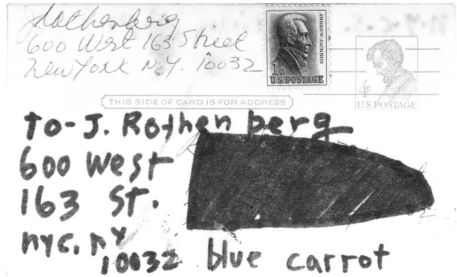

125 Wolf Vostell, *Das Theater ist auf der Strasse*, 1958

15.0 × 10.5 cm (6 × 4¼ in.)
Postcard announcement of publication by
Edition Hake, Cologne, applied with unique
paper collage

On a small number of these announcement
cards Wolf Vostell glued collages of torn paper
to the centre of the graphic design, in this case
two coloured scraps. This particular example
comes from the archives of Gerd von Koff,
founder of Galerie Aachen. With strong critical
views of the political establishment, Vostell
was a European member of the Fluxus movement,
performing his 'de-coll/ge Happenings', a phrase
he had adopted in the mid-1950s. These
qualities were demonstrated in his one-hundred
event performance in Berlin in 1965, enumerated
by him in *Berlin and Phenomena* (1966), which
was published as a Great Bear pamphlet by
Dick Higgins's Something Else Press.

Wolf Vostell: Das Theater ist auf der Straße
Holzkassette, 40 x 40 cm., mit 6 Originalverwischun-
gen und Dé-coll/ageplakaten in Plastikfolie einge-
schweißt und einem Objekt Liegewiese. Alle Blätter
und das Objekt sind signierte Originale.
Text: Das Theater ist auf der Straße (1958).
25 Exemplare DM 600,–

edition hake herausgegeben von walter aue
5000 köln-kalk · odenwaldstrasse 9 · ruf: 85 16 42

126 Genesis P-Orridge, *Untitled*, 1973
10.4 × 8.5 cm (4 ⅛ × 3 ⅜ in.)
Unique collaged postcard on self-published
PASTCORD, blank with numerous rubber
stamps on reverse, signed and dated
1 June 1973

The image side of this postcard was made of
cut-up pieces of Genesis P-Orridge's printed
PASTCORD *Mum/Dad* (1973), in which he
pursued the idea of reuniting his separated
parents. He posted this card from York to Paul
Brown in Deal, Kent. Brown was the founder
of Transgravity and instigator of a proposed
mail-art postcard show in 1973. P-Orridge
was summonsed to court by the General
Post Office in 1975, accused of posting
indecent collaged postcards of the Queen.
In a statement of 5 April 1976, P-Orridge
explained his use of postcards as a method
of maintaining a place for his own work within
popular culture, not as 'an intellectual artist, in
an ivory tower, thinking I am special, revered
and monumental'.[49]

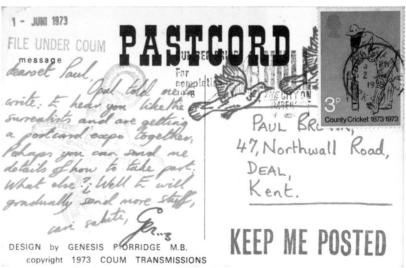

127 Angus Fairhurst, *Matterhorn –*
***Gridded*, 1989**
10.5 × 15.0 cm (4¼ × 6 in.)
Found postcard of the Matterhorn, blocked out
with felt-tip pen, signed and dated on reverse

Angus Fairhurst left art college at Goldsmiths,
London, in 1988, shortly after exhibiting in
the 'Freeze' show (fig. 179), organized by his
friend Damien Hirst, with whom he was sharing
a studio at the time of making this postcard.
Use of an overlaid grid directly reflects his and
Hirst's creative interests at the time. Fairhurst
also made a series of over one hundred works
under the generic title *All Evidence of Man
Removed*, using found postcards and cutting
out with a scalpel all signs of human presence.

128 Andy Parker, *Lading (7)*, 2010
9.0 × 14.0 cm (3 ⅝ × 5 ⅝ in.)
Painted in black acrylic on found postcard,
stamped, monogrammed and dated on reverse

Andy Parker's interventions on found postcards
often explore the subject of ships and boats,
adding acrylic container loads with the illusion
that they are tied to the vessels. The subject
had a particular resonance for him because
his father used to send him postcards while he
was away at sea on merchant ships. The family
lived in Portsmouth, famous for its dockyard
and naval base. Parker's mother also had a
connection to the sea, as she was born on the
small island of St Helena. At art school Parker
began to make use of postcards, sending them
to friends and painting on them. He still works
with postcards, buying them at out-of-the-way
charity shops and London markets.

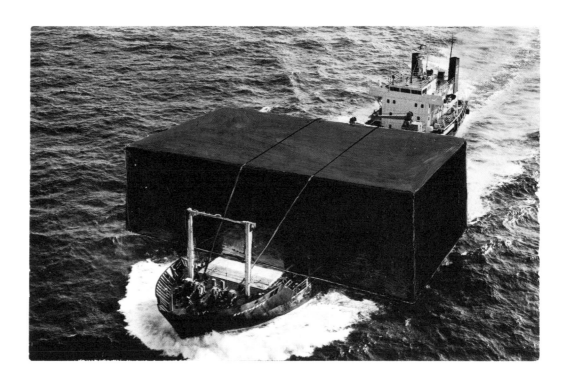

129 Rachel Whiteread, *Untitled*, **2005**
10.5 × 15.0 cm (4¼ × 6 in.)
Found 1960s tourist postcard of alpine scene,
with punched holes

Rachel Whiteread has collected postcards
from an early age, influenced by her mother,
who was also an artist. She works on these
cards as single individual pieces and also uses
them for inspiration in her sculptural works. This
interest in postcards first came to light at her
drawings exhibition at the Hammer Museum,
Los Angeles, in 2010. *Water Tower*, which
was erected in SoHo, New York, in 1998 was
directly inspired by her postcard collection,
drawing on the forms of the Llyn Brianne
Dam in Llandovery, Kents Cavern in Torquay
and the Archimedes system of irrigation
in Egypt. Whiteread's individually worked
postcards become two-dimensional sculptures,
inseparable from her larger work.

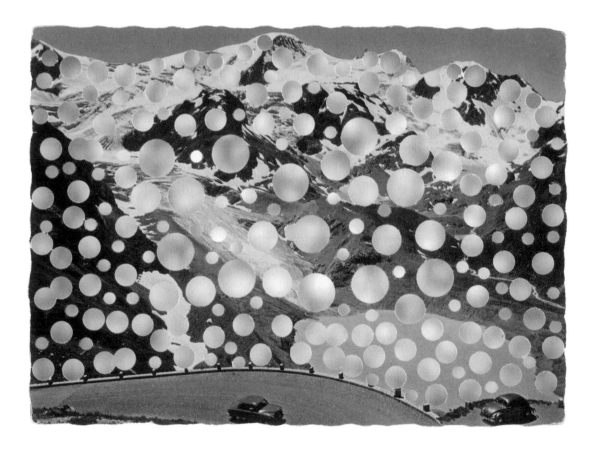

130 Cristina Garrido, *Untitled*, 2011
10.5 × 15.0 cm (4¼ × 6 in.)
Tate postcard of Rachel Whiteread's *Untitled (Air Bed II)*, 1992, with mattress painted out in acrylic

A series of postcard works were made by Cristina Garrido while studying in 2011 for her MA at Wimbledon College of Arts, London, where her final show was made entirely of postcard-related material. These postcards were among the first group of a continuing series titled *Veil of Invisibility*. In an email to the author, the artist commented: 'My intervention consists in partially concealing the artwork from the postcard. This removal is negative only in appearance, as, on the mechanically reproduced artwork, I add a layer of paint that turns the postcard into a unique object, altering its perceived value.'[50]

6. Portrait Postcards

Artists' postcards often print portrait images that are little known to a wider public, on occasion absent in any other published source.

In 1969 an important series of video exhibitions on Land Art was organized by Gerry Schum in various locations throughout Europe. The images chosen for the invitations use stills from videos featuring the artists in person, including Richard Long, Barry Flanagan, Walter de Maria, Michael Heizer, Joseph Beuys and Lawrence Weiner. Weiner personally appears in both his videos shown at the Fernsehgalerie Gerry Schum in Hanover in 1970, *Beached* (fig. 44) in October and *Untitled (To the Sea)* in November. Over the next couple of years Schum invitations also featured intriguing portraits of Keith Arnatt (fig. 135), Franz Erhard Walther, Gilbert & George, Mario Merz and Alighiero Boetti.

Portrait postcards of less well-known figures are instructive, directing attention to undeservedly neglected artists. Some of these images are of notable aesthetic quality. The Mexican book designer and poet Ulises Carrión, who moved in 1972 to live in Holland, was admired by avant-garde European artists in the 1970s. A rare photograph of him, titled *Seeing Mail*, with crumpled paper lodged behind his spectacles, was published as a postcard in 1981 (fig. 134), an image otherwise known only from the illustration accompanying publication alongside Carrión's essay 'The New Art of Making Books' in his magazine *Kontexts* in 1979. He made an equally inventive companion postcard titled *Eating Mail*.

Peter Hutchinson, an art-world habitué in New York during the 1970s and 1980s, receives scant notice these days, despite the appeal of the invitation image *Struggling with Language* for his 1974 show at the John Gibson Gallery, New York (fig. 136). Gibson was one of the leading exhibitors of Story Art, with his first show on the theme in 1973, including work by Hutchinson and Baldessari. In the postcard *God Saw I Was a Dog* (1976), Hutchinson superimposed an image of his pet dog over a colour photograph of his own face.

Guglielmo Achille Cavellini created equally bizarre self-images for his postcard invitations (fig. 145). The illustration on Cavellini's postcard invitation to his exhibition '25 Lettere'

in Milan in 1974 envisages a large billboard hanging on scaffolding at the front of the cathedral, supposedly promoting a show of his work at the Palazzo Reale, in which the artist gives his dates as 1914–2014 (they were, in fact, 1914–90). The twenty-five letters were written by Cavellini to those who supposedly published books about him, beginning with a cod-letter of 16 June 1460 to 'Mr Gutenberg' and ending at the then-future date of 1 May 1978 in a letter to Mao Tse Tung. For the preview party Cavellini wore a white cotton suit printed with a facsimile of his handwritten life story.

Ben Vautier was the author of two classic early Fluxus postcards, the performance piece *je suis art* (fig. 133) and *The Postman's Choice* (fig. 19). Over the years Vautier has self-published hundreds of slogan postcards, usually in his own script in white on black, sometimes reversed into black on white. Vautier consistently uses photos of himself in postcards, making in 1986 a large postcard invitation to a show in Geneva called 'Blanco! de Ben'. The bled image on the front is of Vautier seated in the sun outside his home in Nice, mirroring the gesture in a large portrait painting propped at his side. The building is covered in found and made material, including a handwritten plaque characteristic of Vautier, reading 'l'essential est que je communique'. Another simply says 'DADA'.

From 2005 until his death in 2018 the Fluxus artist Geoff Hendricks made a series of self-portrait postcards standing on his head and holding banners between his toes, including *Headstand for Ben Vautier, 27 April 2008*, on the street outside Vautier's home, Chez Malabar et Cunégonde, Nice. The postcards were published by Hendricks himself, at Money For Food Press in New York.

Artists' postcards confirm and embroider inner narratives of how the private world of art actually worked, pointing towards unexpected relationships and connections, as in the Carolee Schneemann seasonal postcard of 1971 (fig. 142). Unremembered installations are documented, by Urs Lüthi, for example (fig. 144), communicating in the present day through these ephemeral objects from the past something of what it may have felt like to be there.

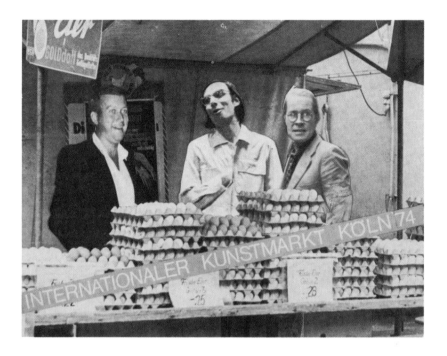

Rolf Rose David Hockney
 Hans Neuendorf
J. Kasmin Florentine Pabst

im Herbst 1968 auf dem Hamburger Dom

**131 Klaus vom Bruch, *Konrad Fischer
and Heiner Friedrich*, 1974**
10.8 × 14.1 cm (4 3/8 × 5 5/8 in.)
Postcard-sized photo cardstock of a collage by
Klaus vom Bruch, rubber-stamped on the reverse

The composite collaged image, a design for a
postcard that was never made, focuses on two
of the leading German dealers in contemporary
art of the 1970s, in the centre Konrad Fischer
from Düsseldorf and on the right Heiner
Friedrich from Munich. The figure on the left
has not yet been identified. Instead of art, the
dealers are shown selling eggs at a market
stall, with the additional collage of a banner
reading 'Internationaler Kunst Markt Köln
'74'. Fischer opened his gallery in 1967. While
Heiner Friedrich and his wife Philippa de Menil
set up the Dia Art Foundation in 1973. Klaus
vom Bruch studied at Cal Arts, where he was
taught by John Baldessari, from 1975 to 1976,
later concentrating on video art.

**132 David Hockney, *Pictures and
Drawings from 1961 to 1975*, 1968/1977**
15.0 × 10.5 cm (6 × 4 1/4 in.)
Postcard announcement of exhibition
from 21 April to 20 May 1977 at Galerie
Neuendorf, Hamburg

The black-and-white photograph on the front
of the postcard was taken in Hamburg in 1968.
It shows (top left, clockwise) the artists Rolf
Rose and David Hockney, the dealer Hans
Neuendorf, the journalist Florentine Pabst and
John Kasmin, a long-term collector of pre-1920
postcards and the first central London dealer
to exhibit Hockney, whom he represented
for many years. This invitation was posted to
Galerie Rolf Ricke in Cologne.

133 Ben Vautier, *je suis art*, 1964/1972
10.5 × 15.0 cm (4¼ × 6 in.)
Photograph taken in 1964 by the Stedelijk
curator Ad Petersen of Ben Vautier's
performance at the Fluxus event in Rue Tonduti
de l'Escarène, Nice, issued as a postcard by
Edition Stedelijk, Amsterdam, in 1972

This snap of Ben Vautier in the street in Nice
in 1964, together with a related photograph
from the same year of him tied up in string
to perform a concert in Canal Street, New
York, are the best known early images of the
artist. He had already contributed to an event
in London in 1962, equipping Gallery One in
North Audley Street, Mayfair, for his Festival
of Misfits, selling things which, in the words of
Vautier's brochure, 'give us the chance to enjoy
a happy, non-specialized fantasy'.[51]

134 Ulises Carrión, *Seeing Mail*, 1979/1981
12.8 × 9.1 cm (5 ⅛ × 3 ⅝ in.)
Postcard published by OBAS Archive,
Amsterdam, the portrait photograph by
John Liggins

This image was first published in the magazine
Kontexts in 1979, accompanying the Mexican
poet Ulises Carrión's essay 'The New Art of
Making Books'. The photographer John Liggins
was a mail-art specialist based in Amsterdam,
where he used collage in imaginative forms.
Carrión moved to the Netherlands in 1972
to co-found with Raúl Marroquin, Gerrit Jan
de Rook and others the artists' cooperative
Out Center. When this closed in 1974, he
set up in 1975 his own gallery and bookshop
in Amsterdam, Other Books and So, the
first of its kind. Carrión became a leading
figure in developing the artist's book, in theory
and practice.

135 Keith Arnatt, *Self-Burial TV Project*, 1969
10.5 × 14.5 cm (4¼ × 5¾ in.)
Postcard announcement from Fernsehgalerie
Gerry Schum for WDR TV broadcast of
Self-Burial TV Project, 11–18 October 1969

This first image of nine shots broadcast
consecutively, in which the artist is seen burying
himself deeper and deeper in a hole. In the photo
before last, he is up to his chin, while in the last
there is an image of disturbed earth, implying his
total burial beneath the ground. *Self-Burial TV
Project* and Jan Dibbets's *TV as a Fireplace* (fig.
47), also of 1969, were the only Schum TV films
to receive a wide audience, because they were
broadcast by Westdeutsches Fernsehen. Arnatt
told the Stedelijk Museum, Amsterdam, on the
occasion of their 1980 exhibition on Schum's video
project: '*Self-Burial* was originally made as a
comment upon the notion of the "disappearance
of the art object". It seemed a logical corollary
that the artist should also disappear.'[52]

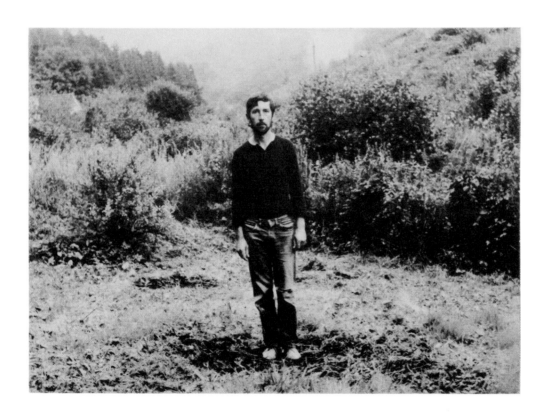

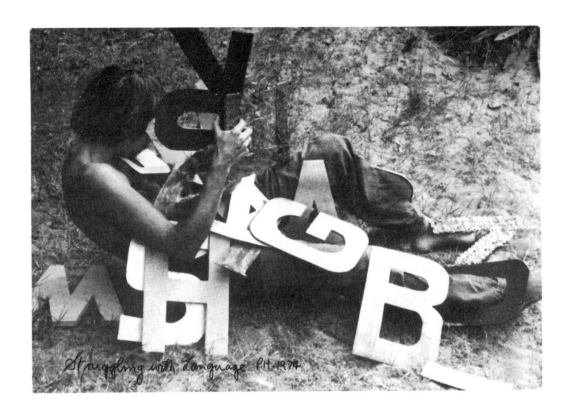

136 Peter Hutchinson, *Struggling with Language*, 1974
10.5 × 15.0 cm (4¼ × 6 in.)
Postcard invitation to opening of *Alphabet Series* on 19 October 1974 at John Gibson Gallery, New York

In 1970 Peter Hutchinson made a series of works titled *The End of Letters T*, in which pigeons ate breadcrumbs laid out in the shape of a capital T. Visual use of letters in this way can be seen as part of concrete poetry. This movement was exemplified in the mid-1970s by the performance piece *These Letters Are My Flesh And Blood* (1976) by Beau Geste Press coordinator Michael Gibbs, in which he wrote in his own blood on paper pinned to a blackboard. The art critic Carter Ratcliff described Hutchinson as 'a restless innovator, he has been particularly successful in reshaping the relations between language and photographic imagery'.[53]

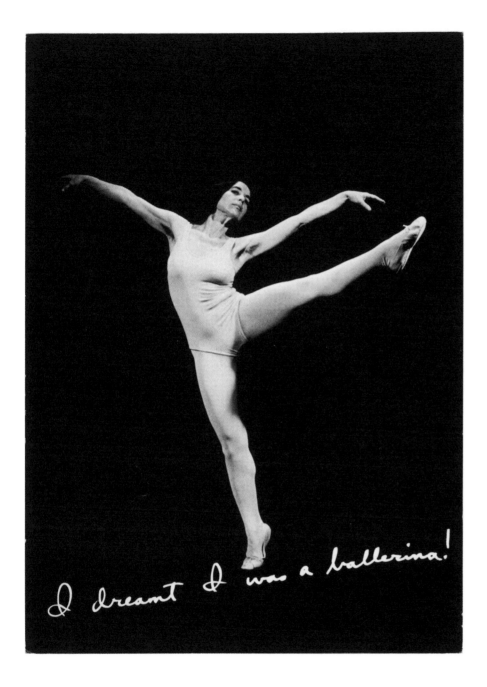

I dreamt I was a ballerina!

137 Eleanor Antin, *I dreamt I was a ballerina!*, 1973
16.5 × 12.0 cm (6½ × 4¾ in.)
Postcard invitation to opening on 5 October
1973 at Orlando Gallery, Encino, California

Eleanor Antin has regularly taken on the
persona of invented historical characters in
her work, one of whom she called Eleanora
Antinova, whom she defined as the first
black dancer with Diaghilev's Ballets Russes.
For this image Antin was photographed by
Philip Steinmetz in deliberately archaic style,
personally enacting her dream of being a prima
ballerina. Another of Antin's favourite characters
was the King; postcards of her in this role show
her in beard, flamboyant hat and cloak. Other
fictional characters included Little Nurse Eleanor,
Nurse Eleanor Nightingale and Yevgeny Antinov.

138 Jim Dine, *Jim Dine*, 1973
20.5 × 20.5 cm (8 ⅛ × 8 ⅛ in.)
Postcard invitation to opening on 24 February
1973 of solo exhibition at Sonnabend Gallery,
New York

This invitation, with a photographic portrait
on the front by Jim Dine's eldest son Jeremy,
was posted to the art patron Mrs Maxwell
Myers in San Francisco. Dine had been closely
involved with Allan Kaprow's Happenings and
participated in early Fluxus events. At the Ray
Gun Specs programme at Judson Memorial
Church, New York, between 1959 and 1960,
Jim Dine, Claes Oldenburg and Lucas Samaras
together performed a Kaprow Happening. This
image of Dine shows him with a full beard and
bowler hat, whereas he is beardless and wearing
a flat cap in his etched self-portrait of 1974.

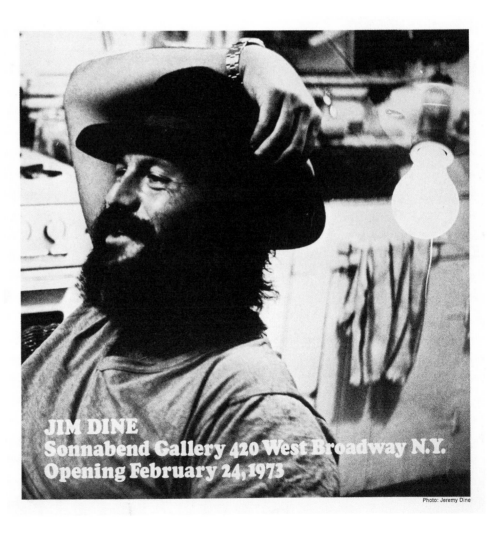

JIM DINE
Sonnabend Gallery 420 West Broadway N.Y.
Opening February 24, 1973

Photo: Jeremy Dine

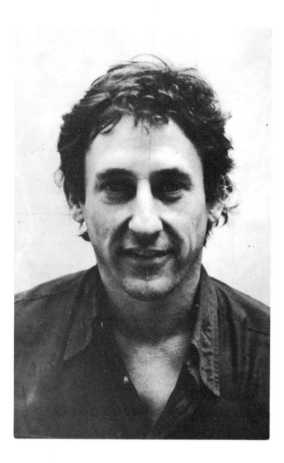

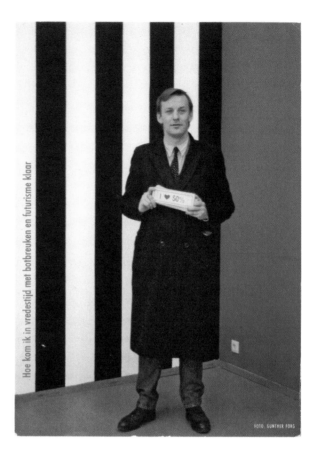

139 Edward Ruscha, *Edward Ruscha Books*, 1978
15.0 × 10.5 cm (6 × 4 ¼ in)
Postcard invitation to opening on 16 March 1978
at Galerie Rüdiger Schöttle, Munich

The books that Edward Ruscha made in
California in the early 1960s were crucial in
establishing the Artist's Book as a significant
outlet for creative experiment. The sixteenth
and last of this group of books appeared
in 1978, the year of this Munich show, the
invitation using an informal photo of Ruscha.

140 Martin Kippenberger,
***Martin Kippenberger*, 1985**
21.0 × 15.0 cm (8 ⅜ × 6 in.)
Postcard invitation to opening on 23 March
1985 at Galerie van Beveren, Rotterdam,
illustrating a photograph of the artist taken
by Günther Förg

Translated into English, the full title of this
show reads: *How can I come to terms with
bone fracture and futurism in times of war.*
Martin Kippenberger was a prolifically inventive
artist who regularly made use of posters and
postcards in his work. This example is more
formal than other highly personal postcards,
which often had handwriting over the images.
He was due to design advertising material for
Schlik/Steirischer but died in 1997 before
executing the commission, aged only forty-four.

**141 Gerard Malanga, *Andy Warhol
and Parker Tyler*, 1969/1981**

13.9 × 8.8 cm (5 ½ × 3 ½ in.)
Photograph taken in New York City in 1969
published as a postcard in 1981 by the Bellevue
Press, New York

The poet and photographer Gerard Malanga
was a close friend of Andy Warhol in the
1960s, helping him with screen tests and films,
which provided access to personal, unposed
moments as captured in this image. In 1966
Malanga's own film work was shown by the
London Film Co-operative in their inaugural
events at Better Books in Charing Cross Road,
London. The film critic Parker Tyler died in 1974
at the age of seventy, having campaigned all
his life for gay rights. The Bellevue Press was
founded in the 1970s by Gil and Deborah
Williams, to publish poetry postcards as well
as portrait postcards by Malanga and other
photographer friends.

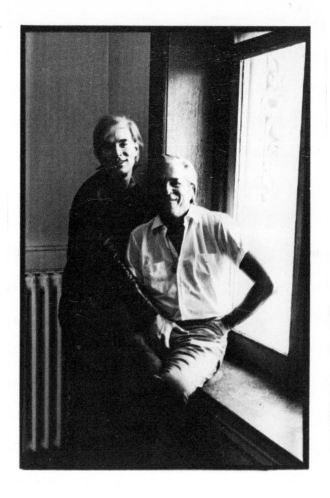

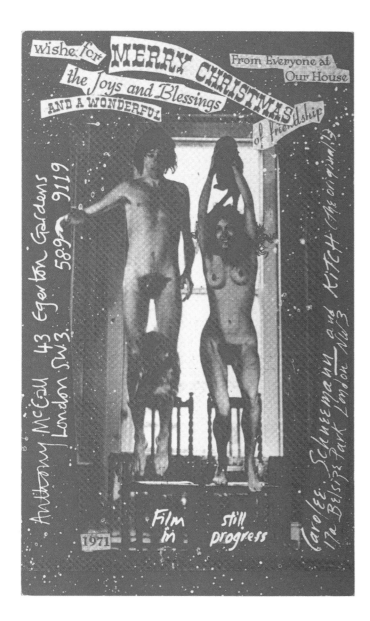

142 Carolee Schneemann, *Wishe for Merry Christmas of Friendship*, 1971
15.0 × 9.0 cm (6 × 3 ⅝ in.)
Privately printed postcard sent by Carolee Schneemann and Anthony McCall as Christmas greetings, the reverse of this example with a handwritten note by Schneemann dated 27 February 1972

Carolee Schneemann met the British film artist Anthony McCall when she was based in London in 1971. The card lists different London addresses for them at the time of printing in the winter of 1971, with McCall in South Kensington and Schneemann in Belsize Park. They lived together from then until 1976, moving to New York in 1973. The image on the front, printed in red, is a choreographed photograph of the two artists, naked, jumping from chairs. Schneemann is holding her cat Kitch above her head, but McCall has dropped his cat, Bathsheba. Schneeman often referred to cats in her artwork, poems and writings, and made Kitch the subject of a series of short films documenting the meals it ate each week from the age of sixteen until it died, titled *Kitch's Last Meal* (1973–78). In January 1971 Schneemann participated in the *Festum Fluxorum* performance presented in Berlin by Galerie René Block.

143 Hannah Wilke, *Intra-Venus*, Exhibition postcard at Ronald Feldman Gallery, 1994
15.3 × 10.8 cm (6 × 4 ¼ in.)
Postcard invitation to opening of posthumous exhibition on 8 January 1994 at Ronald Feldman Fine Arts, New York. Courtesy Donald and Helen Goddard and Ronald Feldman Gallery, New York

Intra-Venus (1992–93) was Wilke's final work, the photographic record of devastation to her body after she had undergone chemotherapy and bone-marrow transplant. These images were taken at the artist's direction by her husband Donald Godard. Throughout her life Wilke had made her own body the focus of her work (fig. 36). She left instructions that this revealing last work be exhibited as soon as possible after her death. This invitation was sent to Eleanor and David Antin at their home in Del Mar, California. Eleanor Antin was a friend of Hannah Wilke's, and both were represented by Ronald Feldman.

**144 Urs Lüthi, *'Something like falling
off the world'*, 1979**
11.4 × 16.4 cm (4 ½ × 6 ½ in.)
Postcard invitation to opening on 13 September
1979 at Galerie ak, Frankfurt

After completing his studies in Zurich in the
mid-1960s, the Swiss artist Urs Lüthi began
painting. In 1969 he started to concentrate
on photography, largely in semi-disguised self-
portraiture, much of the time exploring the idea
of the false twin. Eleven years later he ceased
working with photography and returned to
painting, and then taking up sculpture. Galerie
ak was founded in 1974 by Hans Sworowski.
In 1977, Edition AQ issued in Dudweiler,
Germany, an androgynous photographic
self-portrait by Lüthi, illustrating this in their
magazine *AQ 16 Fluxus*.

Opposite
**145 Guglielmo Achille Cavellini,
Cavellini 1914–2014, c. 1980**
14.7 × 13.4 cm (5 ⅞ × 5 ⅜ in.)
Postcard issued from 16 via Bonomelli, Brescia

The image is of G. A. Cavellini dressed in
his *1914–2014* stickers, holding a blown-
up version of the image for an exhibition
at the Palazzo Ducale, Venice. Another
Cavellini postcard, published in Brescia in
1978, was titled *Ten ways to make yourself
famous*. Cavellini is known for writing his own
biographical details on naked torsos, normally
female, as illustrated on the cover of Anna
Banana's magazine *Vile* in 1977, which she
also published as a postcard. A related
Cavellini postcard image was published
by Image Bank, Vancouver, in 1977.

The image shows a figure in a bodysuit printed with "CAVELLINI" text, pointing to a circular sign that reads: VENEZIA - PALAZZO DUCALE · CAVELLINI 1914-2014 · 7 SETTEMBRE - 27 OTTOBRE

7. Sets of Postcards

Public dissemination of the postcard as a work of art in its own right was effectively promoted by the commissioning of sets of postcards, to be exhibited publicly as postcards and published in designed folders and boxes. The practice began in the late 1960s – the Fluxus set *Monsters Are Inoffensive* of 1967 a notable example (fig. 147) – and continues today, illuminating the aesthetics of particular moments in time.

Two exhilarating double sets of postcards were produced in Vancouver by Image Bank, the first in 1971 (fig. 148) and the second in 1977 (fig. 149). These postcard exhibitions were based on the burgeoning influence of Fluxus, with unusual postcards in the first series by Ant Farm, Joseph Beuys, Dr Brute (Eric Metcalfe), Ray Johnson, Eleanor Antin, Mary Wilson and Art Rat. The founders of Image Bank, Vincent Trasov and Michael Morris, were eager participants in the events of Canadian friends General Idea, calling themselves Michael Morris aka Marcel Dot aka Marcel Idea (Miss General Idea 1972) and Vincent Trasov aka Mr Peanut. Trasov's dress-up character Mr Peanut ran for mayor of Vancouver in 1974, before the artist moved to Berlin in 1981.

In New York in 1977 a set of thirty-nine works were made and exhibited as postcards by the Smithsonian Institution Traveling Exhibition Service, with the accompanying statement: 'each Artist's Postcard carries a new picture created especially for it by a living artist. Since the originals are exactly the same size as the reproductions, the Artists' Postcard images are almost-perfect facsimiles of works that are intended to be known – and that, generally speaking, will be known – as postcards.' Artists' Postcards published a second set, of fifty postcards, in 1978.

The two major postcard sets of the 1990s, Hans Ulrich Obrist's *Hôtel Carlton Palace Chambre 763* (fig. 152) and his related *The Armoire Show* (fig. 153), were inspired by Lucy Lippard's index-card shows, '557,087' in Seattle in 1969 and '955,000' in Vancouver in 1970, using the estimated populations of each city for the title. On moving to Paris in 1993 Obrist borrowed the hotel room of artist friends to present a show that included the uncharacteristic drawing of a baby that On Kawara had made when staying in the same hotel in 1963. The catalogue consisted of postcards of each artist's work in a yellow cardboard drawer-box, including works by Alighiero Boetti, Gilbert & George, Alison Knowles, Urs Lüthi, Michelangelo Pistoletto and Lawrence Weiner.

Some artists published their own postcard sets. Christo relied heavily on the publication of prints and postcards to disseminate a visual record of his projects, which were often too large for single individuals to view and take in. The concertina set of thirty-two postcards *Christo Wrap In Wrap Out* was published in 1969 in a box by the Museum of Contemporary Art, Chicago. It was particularly informative, with high-contrast images taken by the photographic partnership of Harry Shunk and János Kender, including several of the artist himself at work on site, documenting this the first of Christo's museum wraps, made in 1968, the year after MCA's opening. Christo's internal intervention in the museum, *Wrapped Ground*, was repeated in spring 1969 at the commercial gallery Wide White Space in Antwerp.

The French artist Sophie Calle also turned to postcards to illustrate her work. In *Comme si de rien n'était* (1997) she published a concertina book of twenty-four postcards with perforated edges bound within the catalogue of an exhibition held in spring 1990 at the Scottish National Gallery of Modern Art, Edinburgh. With a nod to Calle, Dayanita Singh published through Steidl, Klaus Staeck's publishers, a set of twenty-three postcards in *Blue Book* (2009). The images are of semi-derelict industrial sites taken on her travels around India. Authorship is hidden on the cards themselves behind her pseudonym Dream Villa Productions. Singh's photographic-based work is critical of the status quo, as she said in a BBC Radio 4 talk in January 2017: 'Globalization makes the rich richer and the poor poorer.'

The German artist Eva Leitolf issues her cumulative group of photographs *Postcards from Europe* (2006–ongoing) in the form of both large-scale images and postcards. On to these she prints detailed information about the immigration incidents she documents at national borders. The combined political and artistic use of the postcard in extended sets encapsulates the medium's qualities.

146 Michael Langenstein, *Fantasy and Surreal Postcards*, **1986**
11.0 × 15.0 cm (4 ⅜ × 6 in.)
From complete set of twenty-four photographic postcards of collages, published in tear-out book form by Dover Publications, New York

Described as '24 Ready-to-Mail Photocollages in Full Colour', the publisher Dover suggested that 'New York artist Michael Langenstein has combined creative talent with a slightly bizarre sense of humour to produce this series of zany, attention-getting postcards. Starting with the world's famous cities and symbols, he transforms familiar subjects into unexpected images of sensational contrast.'[54] Soon after moving from Maryland to New York in his late twenties, Langenstein started to publish his collages, notably in 1975 in the *New York Magazine*, which had been founded in 1968 as a competitor to *The New Yorker*.

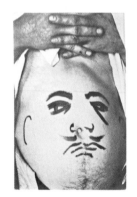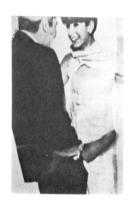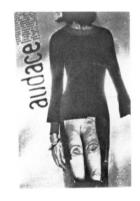

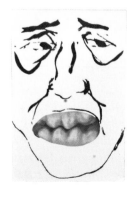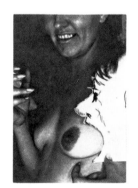

147 Robert Filliou, Daniel Spoerri, Roland Topor, *Monsters Are Inoffensive*, 1967
10.5 × 15.0 cm (4¼ × 6 in.)
Complete set of twenty-two Flux Post Cards published by Fluxus in unmarked envelope

Printed on the reverse: 'FLUX POST CARD. By Filliou-Spoerri-Topor. Photos: Vera Spoerri. 1967, by Fluxus, Division of Implosions Inc.' Contributions were also made by Ben Vautier and other Fluxus artists, including Annie La Rue. The images were created from black-and-white photographs altered by hand, bearing interconnected captions on the reverse, such as 'The fatter men get the sillier they are but MONSTERS ARE INOFFENSIVE.' On the reverse of the back view of a woman with her long black hair gathered at either

side of a face drawn on her neck, another is captioned: 'Women are long on hair and short on etc. but MONSTERS ARE INOFFENSIVE.' The Japanese artist Takako Saito, who had appointed herself George Maciunas's volunteer helper at Fluxus in New York, moving in 1964 to live next door to him in Canal Street, New York, was also involved with this Flux Post Cards project. Saito later made her own postcards, including *Shachspiele + Performance* (1989), a tear-off set of ten, and a number of intriguing pin-prick postcards.

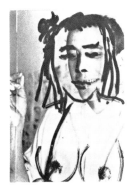

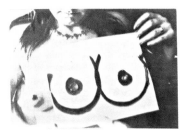
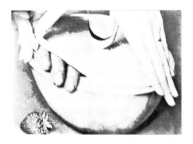

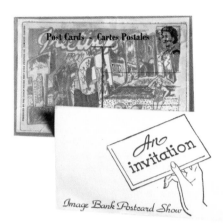

148 Image Bank, *Image Bank Postcard Show*, 1971
8.9 × 14.0 cm (3 ⅝ × 5 ⅝ in.)
Complete boxed set of seventy-six postcards in original box for the exhibition from 13 to 30 October 1971 at the Fine Arts Gallery, University of British Columbia, Vancouver

Vincent Trasov and Michael Morris formed Image Bank in Vancouver in 1969 as a system of postal correspondence between artists. The sets of 1971 and 1977 were the only two postcard series they published. For each set they commissioned postcards from a number of important artists, many of whom produced images unavailable in any form other than these postcards. The year of exhibition of this first set, 1971, was chosen to celebrate the 100th year since the distribution of the first picture postcard. Illustrated postcards, anticlockwise from centre, by Dr Brute, Gary Lee-Nova, Airpress 71 and Tim Mancusi.

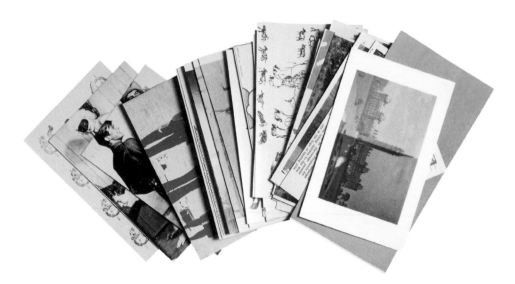

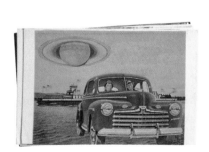

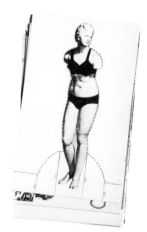

149 Image Bank, *Image Bank Postcard Show*, 1977
9.8 × 15.2 cm (3 ⅞ × 6 in.)
Complete boxed set of forty-eight postcards in original box published by Image Bank, Vancouver, in an edition of c. 750

In 1977 the second Image Bank series was designed and produced. This impressive set of postcards included work by Eleanor Antin, Robert Filliou, Dick Higgins, Davi Det Hompson, Ray Johnson, Allen Jones, Alison Knowles, Sol LeWitt, Gordon Matta-Clark, Hermann Nitsch, Ben Vautier and others. A show titled 'Michael Morris and Vincent Trasov' was mounted in 1979 at John Armleder's Galerie Gaëtan in Geneva, comprising Image Bank photos, documentation and videos. Illustrated postcards, anticlockwise from centre, by James Collins, Robert Mapplethorpe, John Jack Baylin, Dr Brute and Edward Ruscha.

**Image Bank
Post Card
Show**

Vito Acconci
Mac Adams
Eleanor Antin
John Jack Baylin
Jeff Berner
G. A. Cavellini
James Collins
Diego Cortez and
 Katharina Sieverding
Coum Transmissions
Robin Lee Crutchfield
Robert Cumming
Dadaland
Peter Daglish
Lowell Darling
Jimmy de Sana
Mario Diacono
Willian Farley
Robert Filliou
Hervé Fischer
Charles Henri Ford
General Idea
Geoffrey Hendricks
Dick Higgins
Davi Det Hompson

Victor Hugo
Peter Hujar
Ray Johnson
Allen Jones
Marcel Just
Alison Knowles
Richard Kostelanetz
Les Levine
Glenn Lewis
Sol Lewitt
Robert Mapplethorpe
Gordon Matta-Clark
Eric Metcalfe
Michael Morris
Hermann Nitsch
Footsy Nutzle
Tom Phillips
Yvonne Rainer
Clive Robertson
Edward Ruscha
Willoughby Sharp
Vincent Trasov a.k.a.
 Mr. Peanut
Ben Vautier
Allan Zubick

Printed by Rapoport Printing Corp., Zaret Graphics Corp., N.Y.C.
Project Coordination Panama Design Studio, N.Y.C.
Image Bank, 303 E. 9th Ave. Vancouver V5T 1S1 Canada
© 1977 Image Bank Post Card Show L.C. 77-4592

10.5 × 15.0 cm (4¼ × 6 in.)
Complete set of thirty-nine postcards exhibited by the Smithsonian Institution Traveling Exhibition Service, published in New York, in original folder with stickers

Founded in 1977 as a not-for-profit organization, Artists' Postcards aimed 'to bring something new to the American scene – high quality, general circulation postcards made from original works that artists create expressly to be published as postcards'. Contributors included John Cage, Jim Dine, Michael Langenstein and Edward Gorey. Langenstein's postcard depicts the Statue of Liberty swimming past the flood-marooned twin towers of the World Trade Center (fig. 146). Illustrated postcards, clockwise from top right, by John Ashbery, Donald Barthelme, Marilyn Hamann and Lee Krasner.

151 Artists' Postcards, *Artists' Postcards Series II*, 1978
10.5 × 15.0 cm (4¼ × 6 in.)
Complete set of fifty postcards published for
exhibition at the Cooper Hewitt, New York,
in original printed folder

Artists' Postcards Series II, published in
1978, declared its intention 'to explore the
possibilities of the postcard as an art form,
secure broad and new constituencies for the
work of living artists, and encourage the spread
of personal messages from hand to hand'.
The most successful were graphic, by the
poets Jonathan Williams and Dick Higgins
and by the dancer Martha Graham. For his
postcard, David Hockney published the colour
photograph *Swimming Pool, Fire Island*, taken
during his visit in 1975 to the gay resort off
Long Island. Massimo Vignelli in *Heartless*
cut out a tiny heart in a glossy vermilion field.
Illustrated postcards, anticlockwise from top
left, by Carol Anthony, Cecile Gray Bazelon,
Norman B. Colp and Nell Blaine.

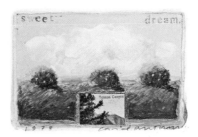

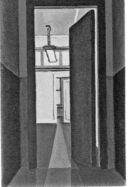

ARTISTS' POSTCARDS, SERIES II, 1978

Artists' Postcards, Inc. is a nonprofit venture
founded in 1977 to bring something new to the
American scene—high quality, general circula-
tion postcards made from original works that
artists create expressly to be published as
postcards.

Artists' Postcards seeks to
—explore the possibilities of the postcard as an
art form
—secure broad and new constituencies for the
work of living artists
—encourage the spread of personal messages
from hand to hand.

One card in each series commemorates a dis-
tinguished American artist who has recently
died: Artists' Postcards II honors the architect
Louis I. Kahn.

Series II consists of 50 cards in varied media,
produced on more than ten different papers, by

diverse printing processes. The artists, each of
whom has contributed one work, are painters,
sculptors, photographers, poets, cartoonists,
writers, filmmakers, architects, and a dancer.
Their names are listed on the reverse.

Available separately is the first Artists' Postcards
Special, a card by Michael Langenstein, which
uses flicker-photo technique and juxtaposes the
twin towers of the World Trade Center with both
the ancient Egyptian desert and the landscape
of the moon.

The original works for Artists' Postcards II are
on exhibition in New York City during Fall, 1978
at the Cooper-Hewitt Museum, the Smith-
sonian Institution's National Museum of Design.

Please address all inquiries to:
Joan K. Davidson, President, Artists' Postcards,
2 East 34 Street, NYC 10016.

152 Hans Ulrich Obrist, *Hôtel Carlton Palace Chambre 763*, 1993
10.5 × 15.0 cm (4¼ × 6 in.)
Selection from complete set of fifty-five postcards in original box published by Oktagon/ Hauser and Wirth in Zurich in an edition of 1,000

Hans Ulrich Obrist invited fifty-five artists to contribute to this exhibition confined to a Paris hotel room, which stemmed from his move to live in the city. The catalogue consisted of a postcard by each artist. Obrist borrowed Room 763 of Hôtel Carlton Palace from two artist friends, opening the exhibition without the knowledge of the hotel management. After good reviews, the show attracted over 3,000 visitors. Radical curatorial ideas were explored, with the artists allowed to remove and replace their exhibits as they wished during the course of the show. Visitors were invited to try on the clothes hanging in the wardrobe and to rifle through Hans-Peter Feldmann's suitcase of archival photographs. The exhibit by one of the artists, Andreas Slominski, was to set Obrist a different daily task, day eight being to clean the member of the hotel staff who was cleaning the room! Illustrated postcards, vertically from top, left to right, by On Kawara (in box), John Armleder, Gerhard Richter, Annette Messager, Rirkrit Tiravanija, Maurizio Cattelan, Edward Ruscha and Reiner Ruthenbeck.

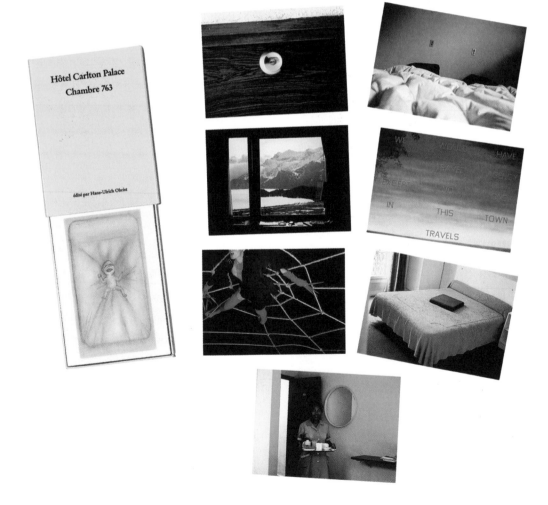

153 Hans Ulrich Obrist, *The Armoire Show*, 1993

10.5 × 15.0 cm (4¼ × 6 in.)
Selection from complete set of ten postcards in original paper band, with printed address of Hôtel Carlton Palace, published in card folder in an edition of *c.* 200

Pursuing the idea of a show within a show, Hans Ulrich Obrist invited ten additional artists to work in and around the wardrobe in Room 763 at Hôtel Carlton Palace, Paris. One of the postcards was from a colour photo portrait by Carl Freedman of the then little-known Tracey Emin and Sarah Lucas (fig. 177), taken in Brick Lane Market, London, near *The Shop*, an art project they ran for six months. Obrist placed the hats worn in the photo on top of the wardrobe. Illustrated postcards vertically from top, left to right, by Wiebke Siem,

Ghada Amer, Straub & Straub, Marie-Ange Guilleminot, Erwin Wurm, Irene and Christine Hohenbüchler, Andreas Exner, Paul-Armand Gette and Fabrice Hybert.

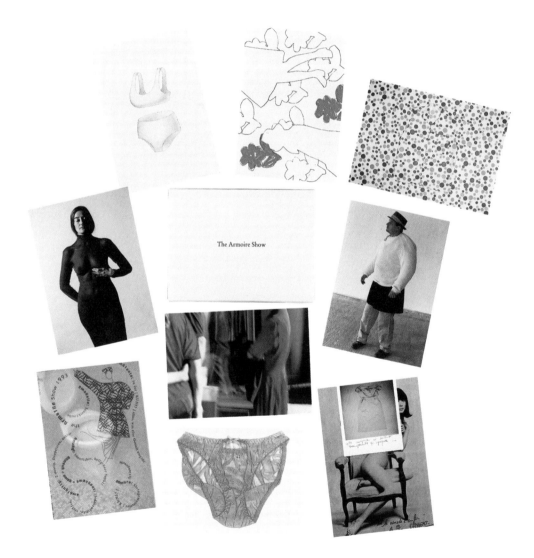

8. Composite Postcards

The term composite postcards denotes a group of postcards gathered into a self-sufficient composition, numbering between two and many more – over 4,000 in the case of Zoe Leonard's *You see I am here after all* (2008) at Dia:Beacon, New York.

Among the most important of this type is *The Flying Spray. The Feathery Foam. Addenda 1. Section 3* by Susan Hiller (fig. 154), constructed of ten found postcards of rough seas together with Hiller's analytical chart of the scenes. A new arrival in England from Florida in the early 1970s, Hiller was fascinated by the craft of making seaside postcards. On noticing that 'tinters' and 'touchers' made fashionably rough seas out of the benign waves at south-coast resorts, she began to collect this narrowly defined category of postcard. In a conversation published in the catalogue for her retrospective exhibition in 2011 at Tate Britain, London, Hiller explained: 'Well, you know that collecting is an attempt to ward off death, I mean, we all know that. I wish to live forever so I can't stop collecting the postcards and making new works out of them.'[55]

In London in the early 1970s Gilbert & George were also making composite works from found postcards, in a form they called 'postcard sculpture'. *Their Crooked House* (1972), uses a central image of a drunk surrounded asymmetrically by old postcards of public houses, reflecting on the environment in which they live in the East End of London. During the 1980s Gilbert & George turned to the use of multiple images of mint commercial postcards in bold decorative compositions, matching and reversing cards.

Originally formed in 1969 by Terry Atkinson, David Bainbridge, Michael Baldwin and Harold Hurrell, the cooperative Art & Language used postcards in a structured grid. According to one of their key collaborators, Charles Harrison, the quotations on the composite postcards *10 Postcards* (fig. 155) 'uphold the mediating power of the artist as intellectual'.[56] The majority of pieces by the artist John Stezaker since 1975 have been in collage, within which postcards are regularly incorporated, including his ongoing *Mask* series, in which colour postcards are collaged over the faces of black-and-white film stills. In *Eros* (1977) Stezaker used five examples of three closely related but different commercial postcards of Piccadilly Circus from the late 1960s to make a composite piece. Similar Piccadilly postcards have also been adapted by Dieter Roth (fig. 13) and Claes Oldenburg. The latter's postcard collage *Lipsticks in Piccadilly Circus, London* (1966), owned by Tate, put in place of the Eros fountain a forest of extended lipsticks, cut from a woman's magazine.

Daniel Buren made a brief physical intervention in the city of Halifax, Nova Scotia. The work was designed to exist thereafter solely in the form of a set of postcards. In April 1973 he decorated an unoccupied building at the corner of Granville Street and Buckingham Street in the city, using different coloured stripes every day for seven days. He photographed the strict rotation of colours from the same position at the same time each day and published these as a set of seven postcards in a printed envelope, with an additional explanatory card (fig. 156). In another composite postcard piece, of 1974, Buren separately posted three different invitations to his triple show 'Division' at Rolf Preisig's gallery in Basel, the postcards together forming the word *TRI-PTY-QUE*. For artists like Buren, whose work is often conceptual and transitory, the publication of postcards is an integral part of the piece.

The photographer Duane Michals constructed a different type of visual progression in his composite postcard piece *Paradise Regained* (fig. 159), like Buren documenting a time-based narrative but centred on people rather than excluding them. More recently, artists such as Zoe Leonard (fig. 157) and Ruth Proctor (fig. 158) add words of their own to their visual structuring of found postcards.

154 Susan Hiller, *The Flying Spray. The Feathery Foam. Addenda 1. Section 3*, 1976
68.0 × 87.0 cm (26 ⅞ × 34 ⅜ in.)
Twelve found postcards of rough seas mounted by the artist with analytical chart of the scenes

On completing her room-sized installation *Dedicated to Unknown Artists* (1972–76), owned by Tate, Susan Hiller found that a number of early postcards depicting rough seas at British coastal resorts were left over, free to be made into a small group of individual pieces focusing on a particular feature from the larger work. The titles echo the postcards' captions,

in this case – one of the earliest, from 1976 – with postcards of Blackpool, Broadstairs, Eastbourne, Hastings and Westcliff-on-Sea. Hiller writes: 'I was intrigued by the fact that these are miniature artworks…Some were produced on the day of sale by photographers who were at one time very well known but later became anonymous.'[57]

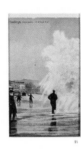

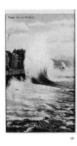

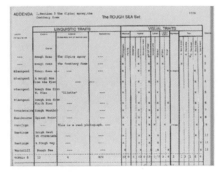

10.5 × 15.0 cm (4¼ × 6 in.)
Complete set of ten postcards published by
Robert Self in original printed envelope in an
edition of 250

The cooperative Art & Language became
known for the magazine called *Art-Language*,
which they began to publish in 1969.
Instrumental in establishing in Britain the
word as a work of art, Art & Language had
a solo exhibition at the Robert Self Gallery,
London, in 1977, at which this graphic set was
exhibited. They also installed ten postcards in
a different room, fragments from *10 Postcards*
'recomposed into a travesty of "ambitious"
modern paintings'.[58] The backs of the postcards
list the sources of the quotations: *An Anti-
Catalog*, the Catalog Committee, New York,
1977; Martin Heidegger, *Erläuterungen zu
Hölderlins Dichtung*, Frankfurt am Main, 1944;
Carl Andre, in *October*, no. 2; and Michel
Foucault, in *Radical Philosophy*, summer 1977.

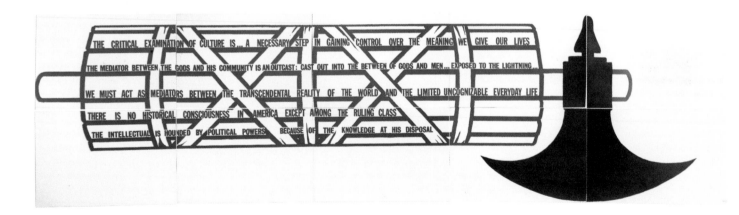

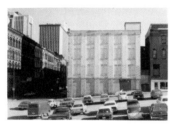
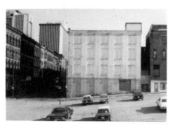
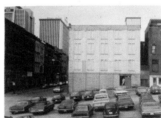
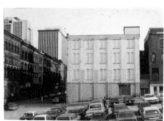

156 Daniel Buren, *Halifax*, 1973/1974
10.5 × 15.0 cm (4¼ × 6 in.)
Set of eight postcards co-published
by Daniel Buren and Multiplicata, Paris

Seven of the eight postcards, which were
all published in 1974, are from photographs
taken over the course of seven days in
April 1973 by Peter Sheppard for the artist.
The backs are captioned, 'Striped papers
white and coloured…glued by Daniel Buren'.
An eighth postcard lists the different colours,
days (from 11 April to 17 April 1973) and
order of placements. Writing in his exhibition
catalogue *Voile/toile, toile/voile: Sail/Canvas,
Canvas/Sail* (1975) at the Akademie der
Künste, Berlin, Buren emphasized: 'Finally,
if there is such a thing as the "reality" of
photography, it is never the same as the "reality"
of the work photographed, and we are not
concerned here with overcoming this gap.'[59]

157 Zoe Leonard, *Untitled*, 2012
8.5 × 13.5 cm (3 ⅜ × 5 ⅜ in.)
Postcard with hand-drawn text. Edition of 100,
made for Camden Arts Centre, London

The Niagara Falls found postcards in this
Untitled series date from the 1920s to the
1950s. They relate to Zoe Leonard's massive
piece *You see I am here after all* (2008),
commissioned by the Dia Foundation and
exhibited at Dia:Beacon, New York, from
September 2008 to January 2011. Leonard
arranged over 4,000 old postcards of the
Niagara Falls on the walls of the gallery, their
position echoing the outline of the Falls, and the
lines of cards mirroring the water's horizon line
and the edges of the Falls disappearing into
the distance. For her show 'Observation Point'
in 2012 at the Camden Arts Centre, London,
Leonard wrote conjugations of the verb 'to be'
in grids on a hundred similar postcards, which
were for sale at the exhibition. Leonard overlaid
these literary points of view onto images of the
Falls to emphasize the position of the viewer in
relation to the world or landscape.

158 Ruth Proctor, *always wanting to be somewhere else*, 2012

10.5 × 14.0 cm (4 ¼ × 5 ⅝ in.)
Composition of four commercial postcards of *c.* 1980, with felt-tip pen overwriting

Four identical postcards gathered piecemeal during Ruth Proctor's six-month residency in Berlin. Slightly battered though unused, the postcards are of the divided city of Berlin, a panorama of West Berlin taken from East Berlin. Proctor has written in felt-tip pen across the postcard images, two mounted upside down. The postcards, which were published by Azet Verlag from original photographs, are captioned on the reverse: 'BERLIN. Reichstagsgebäude, Brandenburger Tor und Tiergarten. Im Hintergrund Panoramablick nach Ost-Berlin.'

In conversation with the author, Proctor said: 'The text is thinking about the movement of a postcard from one place to another and that when it's written it is somewhere other than where it is read.'

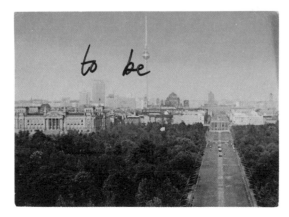

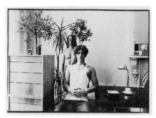

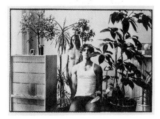

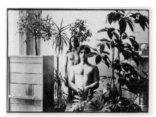

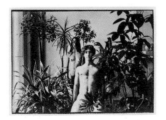

159 Duane Michals, *Paradise Regained*, **1968**
10.5 × 15.0 cm (4¼ × 6 in.)
Complete set of six postcards and labelled envelope with oval window, stating that the set, published by Arrocaria Editions, was edited in Antwerp and distributed from Cologne

This is a key early work in Duane Michals's exploration of self. The six postcards chart the changes in a man and a woman who adopt identical positions in each photograph, going from fully clothed to naked, though they are shielded to some degree by an increasing profusion of interior foliage. Michals himself has commented: 'When we get rid of the hip clothes and the furniture and are taken out of our air-conditioned cars we are essentially like Rousseau's savages.'[60] His first solo exhibition at the Museum of Modern Art, New York, took place in 1970, titled 'Stories by Duane Michals'. Arrocaria Editions was founded by Hervé Würz and Silke Paull, co-editors in the 1970s of the arts magazine *AQ*, published in Frankfurt. Their 1977 issue *AQ 16 Fluxus. How We Met or a microdemystification* prints a number of illustrations of 1960s Happenings unavailable elsewhere, as well as curious verbatim comments by George Maciunas, Ay-O, Ben Vautier, Dick Higgins, Mieko Shiomi and a number of other Fluxus regulars. Arrocaria Editions published original postcard work by Jean Le Gac, Christian Boltanski, Arman (Armand Pierre Fernandez), George Brecht, Annette Messager (fig. 31) and others, documenting Duane Michals's connection to this European artistic milieu.

160 Roland van den Berghe, *New York.*
Four Museums – One Postcard, **1977**
10.5 × 15.0 cm (4¼ × 6 in.)
Complete set of eight postcards

In March 1975 the young Belgian artist Roland
van den Berghe made a postcard at the Profile
Press in New York, titled *First Part of an art
piece,* with a black-and-white self-portrait in the
top right-hand corner and a coloured candle in
the centre. He placed this postcard in the sales
racks at the Whitney Museum of American Art,
Metropolitan Museum of Art and the Solomon
R. Guggenheim Museum in New York and took
black-and-white photographs of his infiltration.
Finally, van den Berghe asked a friend to
purchase the interloper card at the museum
cash desk, recording on camera the bewildered
effect in the expression of the salesperson. The
seven postcards he made of these events were
accompanied by an eighth card listing the titles.

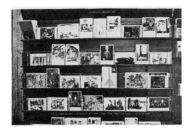

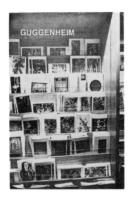

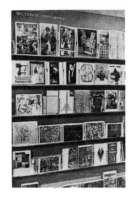

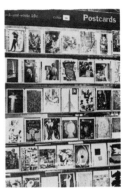

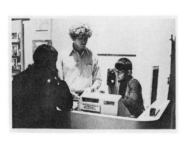

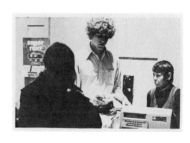

9. Recent Postcards

A promising number of contemporary artists regularly make original postcard pieces, often unique, designed for expression in no alternative form. Some of these artists – such as Gavin Turk (fig. 163), Jeremy Deller (fig. 176), Jonathan Monk (fig. 170), Rachel Whiteread (fig. 129) and Tacita Dean (fig. 172) – are well known for work in other fields, but all create characteristically strong postcards. Although Dean's primary expression is through film, still and moving, at the same time she has always worked with postcards, as in a recent piece for 'documenta 13', for which she overpainted one hundred found pre-war postcards of Kassel with aspects of the contemporary city in the same locations. For other artists the postcard takes a central place: Elisheva Biernoff (fig. 173), ex-assistant to art ephemerist Steven Leiber in San Francisco; the Madrid-based Cristina Garrido (fig. 130); and the Londoner Filippo Caramazza, with his series of precision postcard-sized copies in oil of old-master postcards. Artists also make postcards for use in a promotional form, such as Pipilotti Rist in her poster *Stay Stamina Stay* (2014), designed with perforated edges to be dismantled into thirty-six postcards.

Postcards are perfectly suited to providing a lasting record of art events that might otherwise fade from memory. One of the best-known international contemporary performance artists, Francis Alÿs, makes and publishes postcards of all his work (figs 168, 169). Rod Dickinson, who was involved in all sorts of adventurous artistry in London in the 1990s, has spent most of his time in recent years teaching. Memory of his work relies on paper records. A postcard invitation to Dickinson's Cabinet Gallery show 'Messages of Deception' in 1995 illustrates how he gained notoriety as the rumoured creator of many 'extraterrestrial' crop circles appearing in fields of standing corn in Wiltshire. He had been assiduous in spreading through the British press complex false information about the involvement of aliens in these stunts. For the photograph on the invitation he wore a skull mask. At Factual Nonsense's 'The Fête Worse Than Death' in 1993 Dickinson sold rings of 'crop-circle bread'. Damien Hirst and Angus Fairhurst dressed up as clowns at the same event and sold spin paintings for £1 each, revealing their spot-painted privates for an extra 50p!

In those early days, the Young British Artists (YBAs) made their own postcard invitations, Mat Collishaw designing the 'Freeze' show card (fig. 179) and Gillian Wearing penning her own invitation to *I'm Desperate* in 1993 (fig. 180).

Jeremy Deller employs postcards in a variety of ways, initially for his personal use, such as *The Chelsea Smilers* (1993), dressed up as the invitation to a party at the Shed, the stand at Chelsea Football Ground controlled in the 1980s by this supporters' gang, at a time when Deller used to go to matches there. In 2007 he made a film titled *Procession*, a clip from which the Hayward Gallery, London, published in 2012 as a postcard, *The Unrepentant Smokers*, containing a banner designed by David Hockney.

From the next generation of British artists, Andy Holden has made several postcard-related works in-between putting on solo exhibitions at Kettle's Yard, Cambridge, in 2012, and at the Zabludowicz Collection, London, in 2013, and touring with his band the Grubby Mitts. In 2006 a group of work involved his purloining 78 rpm records from his father's collection and postcards from his mother's collection and painting details of the latter on to the former. Ruth Ewan (fig. 175), a contemporary of Holden's, with a similarly questioning view of today's art market, made in 2013 *The Right of Property in Land*, a four-postcard composition with cut-out words taken from the introduction to William Ogilvie's classic work of liberal philosophy, *Essay on the Right of Property in Land* (1782). Scalpel-cut by Ewan's partner Dan Griffiths on found postcards of aristocratic properties, the work illustrates what Ewan calls her interest 'in seeing how ideas circulate through "unofficial" channels'.[61]

With the aggressive international commercialization of the art world, artist-designed ephemera around exhibitions and events, including postcards, are made less frequently. Postings on social media are today's dominant aesthetic.

161 Richard Tipping, *Multiple Pleasures*, 1996
10.5 × 15.0 cm (4¼ × 6 in.)
From complete set of twenty-four postcards in original plastic wallet published by Thorny Devil Press for the Richard Tipping exhibition, 'Multiple Pleasures', at the Art Gallery of New South Wales, Sydney, 1996

Richard Tipping uses postcards to present his political points humorously, seen in the road signs he has placed across Australia. One of the earliest in this set of postcards, *Airpoet*, first appeared en route to Adelaide Airport in 1979, while the later screen-printed metal signs often present longer subversions. In an essay published in this folder, the poet and architect Alex Selenitsch writes: 'The vision offered by these cards…is a poetic one. Tipping's central preoccupation is literary…His poems and publications ground him in a milieu where an idea is communicated through dispersal rather than a centralized performance or exhibition.'[62]

The Old Man's Hat

January 2, 2008

The Ultra-macho

January 8, 2008

162 Joseph Lammirato, *Ten Postcards From Here*, **2008**
15.0 × 10.5 cm (6 × 4¼ in.)
Complete set of ten self-portrait postcards photographed on successive days, beginning on 1 January 2008, published by Passport Press, contained in original printed paper envelope

An introductory card, with a pseudo 54 cent Canadian stamp showing the head of the artist, reads: 'Ten days, Ten hats, Ten self portraits. Ten Postcards From Here (Plus one Pirate King Hat). Joseph Lammirato. Passport Press 2008.' The postcards are captioned in different ways, the first 'The Bald Man's Cap', the last 'The Birthday Hat', all catching the artist with a look of surprise, even fear – presented in a handmade paper folder with a folded brown paper hat. Lammirato regularly makes use of postcards in his work, mostly exhibited at Ingram Gallery in Toronto.

163 Gavin Turk, *Les Bikes de Bois Rond*, **2010**
10.5 × 15.0 cm (4¼ × 6 in.)
Cover of box and single card from complete set of twenty-two postcards published by Polite

The box sleeve is taken from the single self-portrait postcard modelled on Robert Doisneau's 1949 photo of Jacques Tati. The remainder of the work consists of the twenty-one bicycles made by Gavin Turk from round pieces of wood in homage to the artist André Cadere, painted in the colours of European countries. The bicycles were available at the 2010 Frieze Art Fair for free rides around Regent's Park, London.

164 Julian Opie, *Walking Dancing Undressing Smoking*, 2006
15.0 × 10.5 cm (6 × 4¼ in.)
Black-and-white lenticular postcard, on the reverse a printed invitation to the private view of the exhibition 'Switched On' on 14 October 2006 at the Alan Cristea Gallery, London

On the standard postcard back is a message from the artist, seemingly handwritten, in running capital letters: 'HI THERE. HOPE YOU CAN COME TO MY PRIVATE VIEW ON SAT 14TH OCTOBER '06 (THERE'LL BE PASTRIES + CHAMPAGNE) IF YOU CAN'T MAKE IT DON'T WORRY, THE EXHIBITION RUNS FROM 11TH OCT TO 18TH NOV. BEST WISHES. JULIAN.' Several friends thought that the note was actually from Opie and rang the gallery to accept the invitation and to thank him. One said: 'He must be pretty pushed to send *me* a hand-written invitation.'

165 Anwyl Cooper-Willis, *'The Postcard is a Public Work of Art'* – but should it be?, 2013
10.5 × 15.0 cm (4¼ × 6 in.)
Unique work with clear shipping label printed in black, applied to found 1970s colour postcard of Penzance, signed and dated

This work was made for the show 'The Postcard is a Public Work of Art' at X Marks the Bökship, Bethnal Green, London, in 2014. The title of the exhibition came from a Simon Cutts postcard. Anwyl Cooper-Willis responded to this phrase, printing her own information on a clear label that advised caution at the 'stereotypical Western female figure type'. She has made a number of works that question and play with postcard conventions, often political in implication, examining social balances of power.

166 David Shrigley, *Brilliant*, 2007
10.5 × 15.0 cm (4¼ × 6 in.)
Postcard from David Shrigley's boxed set
25 Cards for writing on published by Polite

David Shrigley makes frequent use of postcards, most of them now published by Polite, who also market ceramics and other multiples by the artist. His large bronze thumb, entitled *Really Good*, gestured on the Fourth Plinth in Trafalgar Square from 2016 to 2018. Shrigley was one of a dynamic group of students at the Environmental Art Department of the Glasgow School of Art in the late 1980s, including Douglas Gordon and Jonathan Monk. These three friends continue to work together on occasion. This postcard references the work of Damien Hirst and the YBA show 'Brilliant!', held from 1995 to 1996 at the Walker Art Center, Minneapolis, where work by Mat Collishaw, Tracey Emin, Angus Fairhurst, Damien Hirst, Sarah Lucas, Gillian Wearing and Rachel Whiteread was exhibited.

167 Fiona Banner, *Buster Gonad and his Unfeasibly Large Testicles. Nose Art on Jaguar XZ118 during Operation Storm 1991*, 2010
10.5 × 15.0 cm (4¼ × 6 in.)
Postcard published by a branch of Fiona Banner's own imprint, the Vanity Press

This is the first postcard that Fiona Banner published at Vanity Press by Post, an offshoot of Vanity Press, founded by the artist in 1997 to print her large book *THE NAM*. Banner made this postcard from a photograph of the nose of an RAF Jaguar XZ118 aeroplane, which had been painted with an image of Buster Gonad from the comic *Viz*, founded by art students Chris and Simon Donald in 1979 in Newcastle upon Tyne. In 2010 Banner installed two decommissioned jet-fighter planes in the Duveen Gallery, Tate Britain, one hanging nose down from the ceiling, and this postcard was published at the same time.

168 Francis Alÿs, *Untitled (the sculpture nobody wanted)*, 2004

10.5 × 14.8 cm (4¼ × 5⅞ in.)
Postcard documentation of walking performance between the Museum of Contemporary Art Australia, Sydney, and the Art Gallery of New South Wales, Sydney, daily from 4 June to 15 August 2004

As with the majority of those performances by Francis Alÿs that did not become video pieces, this work was designed to exist in posterity as a postcard. Ted Purves wrote in Steven Leiber's *Extra Art* (2001): 'No other artist currently explores so thoroughly the use of the postcard as an integral component of his or her works. For every walk that Alÿs has made, he has produced a postcard. The postcards are always available when the walk is displayed, and they are always free.'63

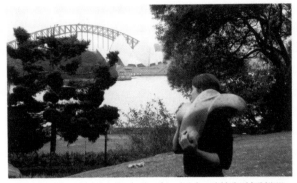

Plot : during the entire period of the biennale, the sculpture is to be carried back and forth between the entry halls of the Museum of Contemporary Art and the Art Gallery of New South Wales, Sydney.
Carrier : anybody volunteering to carry the sculpture.
Route : whatever route the carrier wishes to complete, as long as he/she drops off the sculpture the same day at either venue.

In order to go from Tijuana to San Diego without crossing the Mexico/United States border, I followed a perpendicular route away from the fence and circumnavigated the globe, heading 67° South East, North East and South East again until I reached my departure point. The project remained free and clear of all critical implications beyond the physical displacement of the artist.

169 Francis Alÿs, *The Loop*, 1997/2010

10.5 × 14.8 cm (4¼ × 5⅞ in.)
Subtitled *Tijuana – San Diego* and published as a postcard by Tate (front and back)

Francis Alÿs's *The Loop* was one of the exhibits at his Tate Modern retrospective 'Francis Alÿs: A Story of Deception' in 2010. Displayed solely as a postcard, it was placed in stacks in three Perspex boxes on a shelf. Visitors to the show were allowed to help themselves. It also featured in the book of tear-off postcards published by Tate for the exhibition. Alÿs made *The Loop* in 1997, using his fee for an exhibition in San Diego to take a series of commercial plane journeys to avoid the disputed US–Mexican border, starting from his home near Tijuana and finishing fourteen flights later in San Diego. One of the purposes of the piece was to emphasize the fact that use of this border loophole was available only to the privileged rich. Born in Belgium, Alÿs has for many years been based in Mexico, where the photographer Rafael Ortega has taken many of his still and video images.

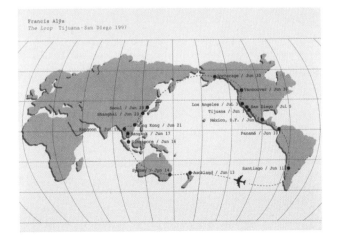

Francis Alÿs
The Loop Tijuana-San Diego 1997

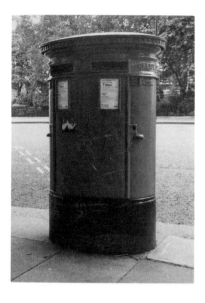

170 Jonathan Monk, *Picture Post Card Posted from Post Box Pictured*, 2003–ongoing
15.0 × 10.5 cm (6 × 4¼ in.)
Front and back of a postcard issued by the Institute of Contemporary Arts, London, in 2005 from complete set of seventeen – to date – in series of uniformly designed postcards issued by various publishers, each in an edition of 200 (front and back)

Made for his solo exhibitions around the world, this work, part of an ongoing series, was begun by Jonathan Monk in 2003 at Revolver in Frankfurt am Main. He photographs the nearest postbox to the location of the show, prints a postcard and sells the edition at the exhibition, to be addressed by the buyers to themselves, signed by the artist and 'posted from post box pictured'.

171 Jonathan Monk, *My Height in HB Pencil*, 2002
10.5 × 15.0 cm (4¼ × 6 in.)
Postcard captioned 'Install this postcard on any wall with the pencil line six feet above the floor', published by Art Metropole, Toronto, in an edition of 200

In this postcard work Jonathan Monk plays with the custom in certain British families of asking their children to stand every year against the kitchen-door frame with a book flat on their head to mark in pencil their changing height, in a different place on the door jamb for each child. Art Metropole, a publisher and an art space that opened in Toronto in 1974, was created by the artist cooperative General Idea. In 2003 Monk published at Lisson Gallery, London, the companion postcard *My Height in Blue Ballpoint Pen.*

172 Tacita Dean, *Lorca's Olive*, **2007**
8.7 × 13.8 cm (3½ × 5½ in.)
Titled on reverse in Spanish: 'El Olivio de
Lorca, Cadaqués' and 'Editorial Fotográfica –
Barcelona', inscribed in pencil: 'Tacita Dean
2007 (for Jeremy Cooper)'

Tacita Dean created *Lorca's Olive* when she
was staying in the Catalan village of Cadaqués
researching a topic for work. Her host related
a story that his grandfather used to tell about
the painter Salvador Dalí and the poet Federico
García Lorca trysting in an olive grove in the
village. Dean looked for the olive grove but
discovered it had been destroyed by a fire,
with only one tree remaining. She photographed
this tree and made it into a fictional postcard
as though it dated from the 1920s, the time of
the alleged affair, putting two coats of silver on
the surface of the black and white photographic
image to give the impression of age.

173 Elisheva Biernoff, *Richard*
Halliburton, **2011 (front and back)**
8.7 × 14.0 cm (3½ × 5 ⅝ in.)
Front and back of plywood postcard painted
in acrylic of Hong Kong harbour, with painted
stamp, postmark, address and invented text
on reverse

In her open-ended series *Last Postcards*,
Elisheva Biernoff imagines the final postcard
sent by an actual explorer prior to his or her
death, unexpected and unexplained. The
postcards accord with the known facts,
including the real-life name and address of the
supposed recipient, the explorer's handwriting,
period postage stamps and postcard design,
all meticulously painted in acrylic on both
sides of card-thin plywood. In an email to
the author, Biernoff explains her choice of a
period view of Hong Kong harbour: 'When
Halliburton disappeared in February 1939, he
was attempting to cross the Pacific from Hong
Kong to San Francisco for the Golden Gate
International Exposition. The plan was a bit of a
publicity stunt – his vessel was more decorative
than anything else.'[64]

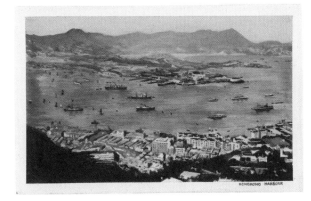

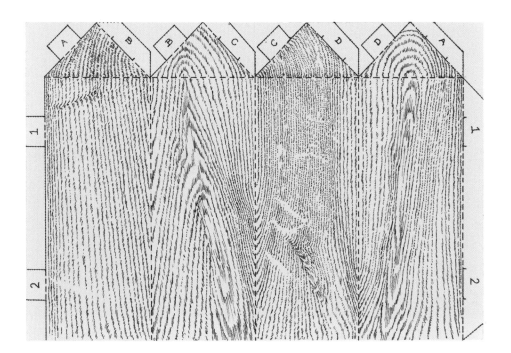

174 Helen Knight, *Post Card*, 2013
10.2 × 15.2 cm (4 ⅛ × 6 in.)
Postcard drawn in black pen, with fold-and-cut marks to enable card to be assembled into a three-dimensional post, drawn on reverse with a stamp-square and 'Make your own SERIES No. 1 POST CARD'

The four panels are precisely drawn from different feather-grained lengths of the old oak floor of the artist's home, designed with numbered lobes and dotted lines to be constructed as a three-dimensional post. In the exhibition 'The Postcard is a Public Work of Art' at X Marks the Bökship in Bethnal Green, London, in 2014, a second version was cut out and assembled as a post, displayed beside this flat version, and later destroyed. Knight has made graphic postcards from her own B Negative blood and a collage of single letters cut from eighteenth-century books.

175 Ruth Ewan, *I will paint your floor green*, 2008
10.4 × 14.7 cm (4 ⅛ × 5 ⅞ in.)
Postcard published by *MAP Magazine*, Glasgow, as part of Ruth Ewan's project *Fang Sang*

Ruth Ewan's multiple work *Fang Sang* was included by the Institute of Contemporary Arts, London, in their exhibition 'Nought to Sixty' in 2008. Ewan made a CD of songs played on guitar and sung by the bohemian poet and guitarist Fang – who lived close to the Byam Shaw School of Art, London, where she was completing her postgraduate fellowship – published together with Ewan's interview of him. The CD and booklet are coloured green, reflecting the statement 'I Will Paint Your Floor Green' that Fang posted in the local press in 1985, here published by *MAP Magazine* as a postcard in 2008.

176 Jeremy Deller, *Mimesis*, 1994
10.2 × 15.2 cm (4 ⅛ × 6 in.)
Self-published postcard, printed by Abacus

After school at Dulwich College, London,
Jeremy Deller studied History of Art at the
Courtauld Institute of Art, London, declining
to go to art school. This postcard is taken
from a photo of Deller kissing the large mural
of a girl with a tiger at Chessington World of
Adventures, near Kingston upon Thames, a few
miles from his boyhood home in Dulwich. A
precedent for this image is the black-and-white
photograph taken in 1964 by the Shunk-
Kender partnership of the artist Martial Raysse
kissing the image of a girl in a street poster in
Paris. Deller retains his interest in public art
at circuses and fairgrounds, forming the Folk
Archive with Alan Kane, with whom he wrote
a book on the subject in 2005.

177 Tracey Emin and Sarah Lucas,
***Big Balls*, 1993**
14.8 × 10.5 cm (5 ⅞ × 4 ¼ in.)
Postcard published by Hans Ulrich Obrist for
The Armoire Show section of *Hôtel Carlton
Palace Chambre 763* in Paris in 1993 in an
edition of *c.* 200

This photograph of Tracey Emin and Sarah
Lucas was taken by the contemporary art
dealer Carl Freedman, on the same day as his
well-known image of the two artists standing
outside their art project *The Shop*, close to
Brick Lane, London. Obrist exhibited the hats
they were wearing on top of the wardrobe
in *The Armoire Show* (fig. 153) at the Hôtel
Carlton Palace. The fruit under the two artists'
arms relates to a story Emin's father told her
about young boys in Cyprus trying to walk like
old men by holding melons under their arms.

178 Tim Noble and Sue Webster,
Tim Noble Sue Webster, **1994**
15.2 × 10.2 cm (6 × 4 ⅛ in.)
Self-made postcard, printed by Abacus

The postcard shows the artist partnership
of Tim Noble and Sue Webster. Their heads
poke through the cut-out of Gilbert & George
that they made for the second 'Fête Worse
Than Death', in Charlotte Road, Shoreditch,
London, in 1994, around the corner from their
studio-home in Rivington Street. The piece
pays homage to Gilbert & George, echoed
in Noble and Webster's caption to their flier
for the event: 'Everything you have ever done
since the day you were born was because you
wanted something.' In November 1997 they
held in Rivington Street their first London solo
show, 'Home Chance: Super Heavyweight Art'
including early shadow sculpture work, bought
in its entirety by Charles Saatchi.

Invitation card designed for private views on
Sunday, 7 August and Sunday, 28 August 1988
at the Port of London building, Docklands, in an
edition of *c.* 500, signed on back in green ink
by Damien Hirst with handwritten note to the
artist Frances Richardson

Damien Hirst and Frances Richardson were in
the same class at primary school, secondary
school and on an art-foundation course in
Leeds. After moving to London, Hirst organized
in 1988 the exhibition 'Freeze' for fellow
Goldsmiths students, who rapidly became
the nucleus of the group referred to as the
Young British Artists (YBAs). The title emerged
from a planning lunch for the exhibition with
Damien Hirst, Angus Fairhurst, Abigail Lane
and Michael Landy, for which Lane prepared
pasta and a salad of Frieze Lettuce. Their
initial choice of 'Frieze' for the title morphed
into 'Freeze', subsequently seen to match the
'freeze-frame' of the piece exhibited by Mat
Collishaw, whose design for the invitation
incorporates a coral motif.

180 Gillian Wearing, *I'm Desperate*, 1993
10.5 × 29.7 cm (4¼ × 11¾ in.)
Postcard invitation to opening on 7 March 1993
at City Racing, Vauxhall, London, the title of the
show handwritten in green felt-tip pen by Gillian
Wearing in an edition of 1,000

This is the first exhibition of Gillian Wearing's
series of photographs *Signs that say what you
want them to say and not Signs that say what
someone else wants you to say* (1992–93),
one of which is of a man in a suit holding up the
self-penned sign 'I'M DESPERATE'. Wearing
herself wrote the exhibition title on each of
the invitation cards. The artist-run space City
Racing closed in 1998 after ten influential
years, two of its five artist-founders, Paul
Noble and Keith Coventry, being represented
by established contemporary-art dealers. City
Racing's groundbreaking shows included Sarah
Lucas's 'Penis Nailed to a Board' in 1992,
Michael Landy's 'Run For Your Life' in 1993 and
Jonathan Monk's 'Crash, Bang, Wallop'
in 1996.

Gillian Wearing
I'M DESPERATE
CITY RACING

60 OVAL MANSIONS, VAUXHALL STREET, LONDON, SE11 OVAL ⊖ VAUXHALL, TEL.071-582 3940 | LONDON ARTS BOARD
PREVIEW: SUNDAY 7 MARCH 6-8PM 8 MARCH - 4 APRIL FRI - SUN 12 - 7 PM & BY APPOINTMENT

181 Mark Wallinger, *Appearing For One Night Only*, 2005

10.5 × 15.0 cm (4¼ × 6 in.)
Complete set of sixteen postcards documenting a poster project for the De La Warr Pavilion in Bexhill-on-Sea, published a month before its re-opening as an art gallery in October 2005

Mark Wallinger devised this set of postcards for his appearance in Bexhill at 8 p.m. on Friday, 16 September 2005. The postcards were made from photographs taken of posters mounted by friends around the world. The locations included an ice-cream stall in Delhi, the side of a fishing boat in Santiago, inside a Maori meetinghouse in New Zealand, a picket fence in Outer Mongolia, a street post outside the Melbourne Museum and the railings of Tate Britain, London.

182 Alan Kane, *Collection of Mr and Mrs L. M. Kane*, 2009
10.5 × 15.0 cm (4¼ × 6 in.)
Complete set of eighteen self-published photographic postcards

Alan Kane distributed free postcards of assorted items from his parents' home at both the Affordable Art Fair and the Frieze Art Fair of 2009. Each of the items was professionally photographed against a blank background, to resemble objects from museums. In addition, precise titles, dates and measurements were included on the back, as if these personal mementoes were national treasures. The objects range from a ceramic of Our Lady of Fatima, a framed sympathy plaque, a Virgin Airline thimble, to a framed photograph of Mr and Mrs Kane meeting Pope John Paul II.

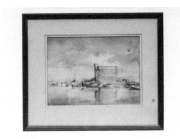
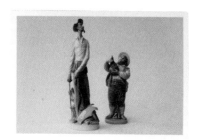

Notes

1 Thomas A. Clark, 'By the Morning Post', in *Souvenirs: 100 Postcards by Ian Hamilton Finlay*, exh. cat., Scottish National Gallery of Art, Edinburgh, 2001.

2 Ellsworth Kelly, *Thumbing Through the Folder: A Dialogue on Art and Architecture with Hans Ulrich Obrist*, Cologne, 2009.

3 Guy Schraenen, *15 Cartes Postales*, Antwerp, 1974.

4 Tacita Dean, *Landscape, Portrait, Still Life*, exh. cat., Royal Academy of Arts, London, 2018.

5 Martha Rosler, *Culture Class*, Berlin, 2013.

6 Lucy R. Lippard, *Six Years: The Dematerialization of the Art Object from 1966 to 1972*, Berkeley, 1997.

7 Susan Hiller, *The Dream and the Word*, London, 2012.

8 Quoted in Gene Ray, *Joseph Beuys: Mapping the Legacy*, New York and Sarasota, 2001.

9 Email to the author, c. 2015.

10 Sara Baume, *A Line Made by Walking*, London, 2017.

11 John Paoletti et al., *No Title: The Collection of Sol LeWitt*, Middletown, Conn., 1981.

12 Richard Hamilton, *Collected Words 1953–1982*, London, 1982.

13 Geoff Hendricks, *A 22 Year Old Manuscript Found in Attic of Artist's New York Residence*, New York, 1999.

14 Ursula Wevers et al., *Ready to Shoot: Fernsehgalerie Gerry Schum*, Düsseldorf, 2003.

15 Emmett Williams and Ann Noël (eds), *Mr Fluxus: A Collective Portrait of George Maciunas 1931–1978*, London, 1997.

16 Ibid.

17 Jeremy Cooper, *Artists' Postcards: A Compendium*, London, 2012.

18 Allan Kaprow, *Some Recent Happenings*, New York, 1966.

19 Rose Lee Goldberg, *Performance*, London, 1979.

20 Al Hansen, *A Primer of Happenings and Time/Space Art*, New York, 1965.

21 Carl Andre, in *Art in America*, vol. 55, no. 1, January/February 1967.

22 Claes Oldenburg, *The Multiples Store*, London, 1996.

23 Vito Acconci, *View*, Oakland, 1979.

24 Willoughby Sharp, in 'Discussions with Heizer, Oppenheim, Smithson', *Avalanche*, no. 1, autumn 1970.

25 Simon Cutts, *Some Forms of Availability*, New York, 2007.

26 Hans Ulrich Obrist (ed.), *More Than You Wanted To Know About John Baldessari: Vol. 2*, Zurich, 2013.

27 John Baldessari, 'Untitled Statement (On Artists' Books)', in *Art-Rite*, no. 14, winter 1976–77.

28 Email to the author, c. 2012.

29 Diane Waldman, *Carl Andre*, exh. cat., Solomon R. Guggenheim Museum, New York, 1970.

30 Sol LeWitt, *Sentences on Conceptual Art*, New York, 1969.

31 Simon Cutts, *Some Forms of Availability*, New York, 2007.

32 Stephen Bann (ed.), *Midway: Letters from Ian Hamilton Finlay to Stephen Bann 1964–69*, London, 2014.

33 Stuart Mills, *Moschatel Press*, Warwick, 1982.

34 Carl Andre, *Cuts. Texts 1959–2004*, ed. James Meyer, Cambridge, MA, 2005.

35 Eleanor Antin, *100 Boots*, Philadelphia, 1999.

36 Michael Compton, *Some Notes on the Work of Richard Long*, London, 1976.

37 Ursula Wevers et al., *Ready to Shoot. Fernsehgalerie Gerry Schum*, Düsseldorf, 2003.

38 Hans Fallada, *Alone in Berlin*, Berlin, 1947; first English translation, New York, 2009.

39 Genesis P-Orridge, *G.P.O. versus G.P-O: A Chronicle of Mail Art on Trial*, New York, 2013.

40 Hans Haacke, *Show and Tell*, Milan, 2010.

41 Phoebe Greenwood, *Nigel Greenwood Inc. Ltd.: Running a Picture Gallery*, London, 2016.

42 Iwona Blazwick, in *Jenny Holzer – Signs / Under a Rock*, exh. cat., Institute of Contemporary Arts, London, 1988.

43 Pierre Bourdieu and Hans Haacke, *Free Exchange*, Cambridge, 1995.

44 *Hans Haacke: Volume II. Works 1978–1983*, Eindhoven and London, 1984.

45 Primary Information, on postcards published in New York from 2016 to ongoing.

46 Email to the author, 2014.

47 Jill Posener, *Spray it Loud*, London, 1982.

48 Bonnie Donahue and Ed Koslow, *Mail Etc., Art – A Traveling Correspondence Art Exhibition*, Colorado, 1980.

49 Genesis P-Orridge, *G.P.O versus G.P-O: A Chronicle of Mail Art on Trial*, New York, 2013.

50 Email to the author, 2012.

51 Institute of Contemporary Arts, *Festival of Misfits*, London, 1962.

52 Wim Crouwel, *Gerry Schum*, exh. cat., Stedelijk Museum, Amsterdam, 1979–80.

53 Peter Hutchinson with Carter Ratcliff and Bill Beckley, *Thrown Rope*, Princeton, 2006.

54 Michael Langenstein, *Fantasy and Surreal Postcards*, New York, 1986.

55 Ann Gallagher (ed.), *Susan Hiller*, London, 2011.

56 Charles Harrison, *Essays on Art and Language*, Cambridge, MA, 2003.

57 Ann Gallagher (ed.), *Susan Hiller*, London, 2011.

58 Charles Harrison, *Essays on Art and Language*, Cambridge, MA, 2003.

59 Daniel Buren, *Voile/toile, toile/voile: Sail/Canvas, Canvas/Sail*, Berlin, 1975.

60 Marco Livingstone, *Duane Michals: Photographs, Sequences, Texts, 1958–64*, Oxford, 1984.

61 Ruth Ewan, *Did you kiss the foot that kicked you?*, London, 2007.

62 Richard Tipping, *Multiple Pleasures*, Sydney, 1996.

63 Steven Leiber, *Extra Art: A Survey of Artists' Ephemera 1960–1999*, San Francisco, 2001.

64 Email to the author, 2012.

Further Reading

Acknowledgments

Gwen Allen, *Artists' Magazines. An Alternative Space for Art*, Cambridge, MA, 2011

Eleanor Antin, *100 Boots*, Philadelphia, 1999

Eleanor Antin, *Being Antinova*, Los Angeles, 1983

Julie Ault (ed.), *Alternative Art New York 1965–1985*, Minneapolis, 2002

Anna Banana, *Go Bananas*, Vancouver, 2015

Michael Bracewell, *The Complete Postcard Art of Gilbert & George 1972–1989,* Munich, 2011

Conceptual Art in Britain 1964–1979, exh. cat., Tate Britain, London, 2016

Jeremy Cooper, *Artists' Postcards: A Compendium*, London, 2012

Simon Cutts, *Some Forms of Availability*, New York, 2007

Anny De Decker and Bernd Lohaus, *Wide White Space 1966–1976*, exh. cat., Düsseldorf, 1994

Jessamyn Fiore, *112 Greene Street, The Early Years (1970–1974)*, New Mexico, 2012

Konrad Fischer, *Ausstellungen bei Konrad Fischer. Düsseldorf Oktober 1967 – Oktober 1992*, exh. cat., Berlin, 1993

Joel Fisher, *View*, Oakland, California, 1981

Rudi Fuchs (introduction), *Ausstellungen bei Konrad Fischer. Düsseldorf November 1992 – Oktober 2007*, exh. cat., Düsseldorf, 2007

Christine Hankinson and Craig Oldham, *Leeds Postcards*, London, 2018

Bärbel Hedinger et al., *Die Künstlerpostkarte*, exh. cat., Altonaer Museum, Hamburg, 1992

Geoff Hendricks (ed.), *Critical Mass: Happenings, Fluxus, Performance, Intermedia and Rutgers University, 1958–1972*, exh. cat., New York, 2002

Bruce Jenkins, *Gordon Matta-Clark: Conical Intersect*, London, 2011

Ray Johnson and William S. Wilson, *A Book About a Book About Death*, exh. cat., Kunstverein, Amsterdam, 2009–10

On Kawara, *Horizontality/Verticality*, exh. cat., Städtische Galerie im Lenbachhaus und Kunstbau, Munich, and Museum Ludwig, Cologne, 2000–1

Thomas Kellein, *The Dream of Fluxus: George Maciunas, An Artist's Biography*, London, 2007

Peter Kennard, *Domesday Book*, Manchester, 1999

Leon Kuhn, *The Big Bang for Bureaucrats*, London, 1983

Carin Kuoni (ed.), *Joseph Beuys in America: Energy Plan for the Western Man: Writings By and Interviews with the Artist*, New York, 1990

Steven Leiber, *Extra Art: A Survey of Artists' Ephemera 1960–1999*, exh. cat., San Francisco, 2001

Lucy R. Lippard, *Six Years: The Dematerialization of the Art Object from 1966 to 1972*, Berkeley, 1997

Richard Long, *Postcards 1968–1982*, exh. cat., Bordeaux, 1984

Hans Ulrich Obrist, *Hotel Carlton Palace Chambre 763*, exh. cat., Cologne, 2014

Clive Phillpot, *Booktrek: Selected Essays on Artists' Books (1972–2010)*, Zurich, 2013

Genesis Breyer P-Orridge, *30 Years of Being Cut Up*, exh. cat., New York, 2009

Jill Posener, *Spray it Loud*, London, 1982

Dieter Roth and Richard Hamilton, *Collaborations of Ch. Rotham*, exh. cat., Stuttgart, 1977

Joan Rothfuss, *Topless Cellist: The Improbable Life of Charlotte Moorman*, Cambridge, MA, 2005

David Senior, *An Invitation to Sol LeWitt*, Ravenna, 2016

David Shrigley et al., *Jonathan Monk. Family of Man*, exh. cat., Kerguéhennec, 2005

Souvenirs: 100 Postcards by Ian Hamilton Finlay, exh. cat., Scottish National Gallery of Art, Edinburgh, 2000

Enrico Sturani, *Cartoline,* Manduria, 2010

Endre Tót, *Book of an Extremely Glad Artist*, Berlin, 1981

Kurt Wettengl, *Fluxus – Art for Everyone. The Braun Lieff Collection*, Dortmund, 2013

Ursula Wevers et al., *Ready to Shoot: Fernsehgalerie Gerry Schum*, exh. cat., Düsseldorf, 2003

Emmett Williams, *My Life in Flux – And Vice Versa*, London, 1992

Emmett Williams and Ann Noël (eds), *Mr Fluxus: A Collective Portrait of George Maciunas 1931–1978*, London, 1997

Jeremy Cooper thanks, very warmly, Simon Cutts for use of one of his wonderful postcards for the title and cover. Gratitude also to those artists who generously gave their work to the collection, now donated to the British Museum and illustrated in this book: Fiona Banner, John Bevis, Anwyl Cooper-Willis, Tacita Dean, Tim Head, Geoff Hendricks, Robin Klassnik (Joel Fisher), Peter Liversidge, Richard Long, Jonathan Monk, Pauline Oliveros, Marsie Scharlatt (Hannah Wilke), Richard Tipping, Gavin Turk, Erica Van Horn, Mark Wallinger and Rachel Whiteread. Thanks also to the many artists who expressed their support for the project by giving Jeremy Cooper permission to illustrate work without charge.

List of Illustration References

Picture Credits

The author and publisher would like to thank the copyright holders for granting permission to reproduce the images illustrated. Every attempt has been made to trace accurate ownership of copyrighted images in this book. Errors and ommissions will be corrected in subsequent editions, provided notification is sent to the publisher.

Page 2 Reproduced by permission of the artist
1 © Yoko Ono 1971
2 © Dieter Roth Estate. Courtesy Hauser & Wirth
3 © Claes Oldenburg. Ben Vautier © ADAGP, Paris and DACS, London 2018
4 © Estate of Gordon Matta-Clark/Artists Rights Society (ARS), New York, DACS London 2018
5 © Stephen Shore. Courtesy 303 Gallery, New York
6–10 © Estate of Richard Hamilton
11 © Dieter Roth Estate. Courtesy Hauser & Wirth
12 © Dieter Roth Estate. Courtesy Hauser & Wirth and © Estate of Richard Hamilton
13 © Dieter Roth Estate. Courtesy Hauser & Wirth
14 Reproduced by permission of the artist
15–18 © DACS 2018
19 © ADAGP, Paris and DACS, London 2018
20 Reproduced by permission of the artist's estate
21 © Dieter Roth Estate. Courtesy Hauser & Wirth
22 © Tom Phillips. All Rights Reserved, DACS 2018
23 Reproduced by permission of the artist
24 © DACS 2018
25 Reproduced by permission of the artists
26 © Carl Andre/DACS, London/VAGA, NY 2018
27, 28 Reproduced by permission of the artist
30 © Marina Abramovic. Courtesy of Marina Abramovic and Sean Kelly Gallery, New York. DACS 2018. Ulay © DACS 2018
31, 32 © ADAGP, Paris and DACS, London 2018
33 © Lynda Benglis/DACS, London/VAGA, NY 2018
34 © DACS 2018
35 © Barbara Kruger. Courtesy Mary Boone Gallery, New York
36, 37 © Marsie, Emanuelle, Damon and Andrew Scharlatt, Hannah Wilke Collection & Archive, Los Angeles/VAGA at ARS, NY and DACS, London
38 © Claes Oldenburg
39 © ARS, NY and DACS, London 2018
40 © DACS 2018
41 Courtesy Allan Kaprow Estate and Hauser & Wirth. Vaughan Rachel © ARS, NY and DACS, London 2018
42, 43 © Bruce Nauman/Artists Rights Society (ARS), New York and DACS, London 2018

44 Reproduced by permission of the artist
45 Reproduced by permission of the Dennis Oppenheim Studio/Archive
46–48 Reproduced by permission of the artist
49 Reproduced by permission of the artist
50 Reproduced by permission of the artist
51 Courtesy of John Baldessari
52 © John Cage Trust
53 © Chris Burden/Licensed by The Chris Burden Estate and DACS 2018
54 © DACS 2018
55 © Paul McCarthy. Courtesy the artist and Hauser & Wirth
56 Reproduced by permission of the artist
57–60 Reproduced by permission of the artists
61 © DACS 2018
62 © DACS 2018
63 © One Million Years Foundation. Courtesy One Million Years Foundation and David Zwirner.
64, 65 Reproduced by permission of the artist
66 © Estate of Roy Lichtenstein/DACS 2018
67 Reproduced by permission of the artist
68 Reproduced by permission of the artist
69 © Peter Doig. All Rights Reserved, DACS 2018. Reproduced by permission of Matthew Higgs
70 Reproduced by permission of the artist
71–73 By courtesy of the Estate of Ian Hamilton Finlay
74 Reproduced by permission of the artist's estate
75 Reproduced by permission of the artist's estate
76, 77 Reproduced by permission of the artist
78 Reproduced by permission of the artist
79 Reproduced by permission of the artist
80 Reproduced by permission of the artist
81 © 2018 The Andy Warhol Foundation for the Visual Arts, Inc./Licensed by DACS, London
82 © Bruce Nauman/Artists Rights Society (ARS), New York and DACS, London 2018
83 © Robert Rauschenberg Foundation/DACS, London/VAGA, NY 2018
84, 85 © DACS 2018
86 © Estate of Gordon Matta-Clark/Artists Rights Society (ARS), New York, DACS London 2018
87 © The Estate of Barry Flanagan/Bridgeman Images
88 Reproduced by permission of the artist
89 © Carl Andre/DACS, London/VAGA, NY 2018
90, 91 © The Estate of Marcel Broodthaers/DACS 2018
92 Reproduced by permission of the artist
93 Reproduced courtesy of the artist
94 © ADAGP, Paris and DACS, London 2018
95 © Bruce McLean. All Rights Reserved, DACS 2018
96 Reproduced by permission of the artist
97 © Jasper Johns/DACS, London/VAGA, NY 2018

98 © Yoko Ono and John Lennon 1969
99 © Jenny Holzer. ARS, NY and DACS, London 2018
100 © DACS, London
101 Reproduced by permission of the estate of Alfred Gescheidt
102 © DACS, London
103 Reproduced by permission of the artist. Courtesy Leeds Postcards
104 Reproduced by permission of the artists
105 © Jonathan Horowitz, courtesy Sadie Coles HQ, London
106 Courtesy Leeds Postcards
107 Reproduced by permission of the artist. Courtesy Leeds Postcards
108 Courtesy Leeds Postcards
109 Reproduced by permission of South Atlantic Souvenirs
110 Courtesy Leeds Postcards
111 Reproduced by permission of the artist
112, 113 Reproduced by permission of the artists
114 © The artist. Courtesy Richard Saltoun Gallery
115 © Guerrilla Girls. Courtesy guerrillagirls.com and Leeds Postcards
116 Reproduced by permission of the artists
117–120 Courtesy the artist
121 © Leon Kuhn
122 Reproduced by permission of Cath Tate. Courtesy Leeds Postcards
123 Courtesy the artists
124 Reproduced by permission of the Ray Johnson Estate and Jerome Rothenberg
125 © DACS 2018
126 Reproduced by permission of the artist. © 1973 Genesis P-Orridge
127 © The Estate of Angus Fairhurst. Courtesy Sadie Coles HQ, London
128 Reproduced by permission of the artist
129 © Rachel Whiteread
130 Reproduced by permission of the artist
131 © DACS 2018
133 © ADAGP, Paris and DACS, London 2018
134 Reproduced by permission of the Carrión Family
135 © Keith Arnatt Estate. All rights reserved. DACS 2018
136 Reproduced by permission of the artist
137 Reproduced by permission of the artist
138 Reproduced by permission of the artist
139 © Ed Ruscha. Reproduced by permission of the artist
140 © Estate of Martin Kippenberger, Galerie Gisela Capitain, Cologne, © Estate Günther Förg, Suisse/VG Bild-Kunst, Bonn 2018
141 © Gerard Malanga
142 © ARS, NY and DACS, London 2018
143 Courtesy of Donald and Helen Goddard and Ronald Feldman Gallery, New York
144 Reproduced by permission of the artist
145 Reproduced by permission of the artist's estate
146 © Robert Langenstein
147 Robert Filliou, Courtesy Estate Robert Filliou & Peter Freeman, Inc. © Estate Robert Filliou. Daniel Spoerri, © DACS 2018, © ADAGP, Paris and DACS, London 2018
148 Reproduced by permission of the artists
149 Below left: Robert Mapplethorpe, Cock

with Star, 1977 © Robert Mapplethorpe Foundation. Used by permission. Above right: © Ed Ruscha. Reproduced by permission of the artist. Below right: Reproduced by permission of the artist
150 Middle right: © The Estate of Donald Barthelme, used by permission of The Wylie Agency (UK) Limited
150 Above right: Estate of John Ashbery, courtesy Tibor de Nagy Gallery, New York. Below left: © The Pollock-Krasner Foundation ARS, NY and DACS, London 2018
151 Top left, centre left: Reproduced by permission of the artist. Below right: © Estate of Nell Blaine, courtesy Tibor de Nagy Gallery, New York
152, 153 Reproduced by permission of H. U. Obrist.
154 Reproduced by permission of the artist
155 Reproduced by permission of the artists
156 © DB-ADAGP Paris and DACS, London 2018
157 © Zoe Leonard. Courtesy the artist, Galerie Gisela Capitain, Cologne and Hauser & Wirth
158 Reproduced by permission of the artist
159 © Duane Michals. Courtesy of DC Moore Gallery, New York
160 Courtesy the artist
161 Reproduced by permission of the artist
162 © DACS 2018
163 Reproduced by permission of the artist
164 Reproduced by permission of the artist
165 Reproduced by permission of the artist
166 © David Shrigley. All Rights Reserved, DACS 2018
167 Reproduced by permission of the artist
168, 169 © Francis Alÿs. Courtesy the artist and David Zwirner
170, 171 Reproduced by permission of the artist
172 Courtesy of the artist, Frith Street Gallery, London, and Marian Goodman Gallery, New York/Paris
173 Reproduced by permission of the artist
174 Reproduced by permission of the artist
175 Reproduced by permission of the artist
176 Reproduced by permission of the artist
177 © Tracey Emin. All rights reserved, DACS 2018
178 Reproduced by permission of the artists
179 © Mat Collishaw. All Rights Reserved, DACS 2018
180 Reproduced by permission of the artist
181 Reproduced by permission of the artist
182 © Alan Kane. All rights reserved, DACS 2018
Page 160 © DB-ADAGP Paris and DACS, London 2018
Cover images, top row: All reproduced by permission of the artists except second from left, which is reproduced by permission of the artist, courtesy Leeds Postcards.
Cover images, bottom row, from left to right: All reproduced by permission of the artists except second from left, which is reproduced by permission of South Atlantic Souvenirs.

Index

Page numbers in *italic* refer to illustrations

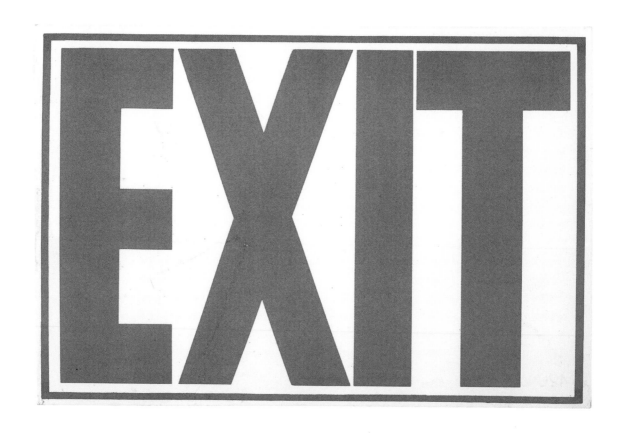